Naïve Art

Grange
BOOKS

Page 4:
The Violin-Player, Mihail Dascalu
oil on canvas, 120 x 80 cm, Private collection

Designed by:
Baseline Co Ltd
19-25 Nguyen Hue, Bitexco Building, Floor 11
District 1, Ho Chi Minh City, Vietnam

ISBN 1-84013-735-5

Published in 2005 by Grange Books
an imprint of Grange Books Plc
The Grange Kingsnorth Industrial Estate
Hoo, nr Rochester, Kent ME3 9ND
www.grangebooks.co.uk

2

Foreword

"The essence of all genuine art is ultimately naïve if we understand this to mean purity of heart and thought."

— Anonymous

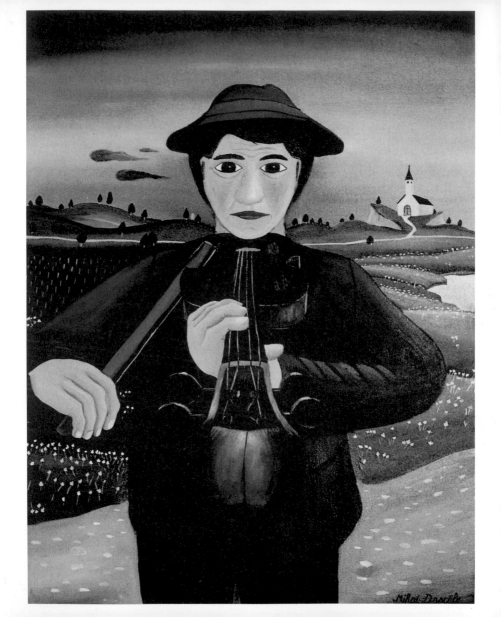

Contents

A. Bauchant

H Rousseau

Michel Delacroix

L. Vivin

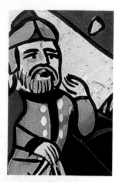

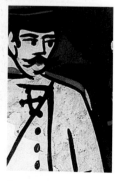

How old is Naïve art?

There are two possible ways of defining when Naïve art originated. One is to assume that it happened when Naïve art was first accepted as an artistic mode of status equal to every other artistic mode. That would date its birth to the early years of the twentieth century.

The War of Independence

Traian Ciucurescu, 1877
Oil on glass, 30 x 25 cm
Private collection

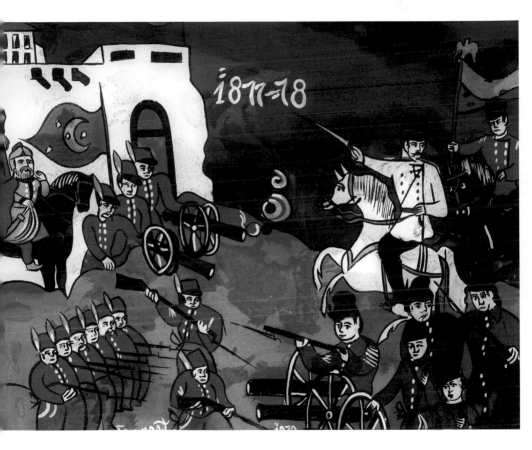

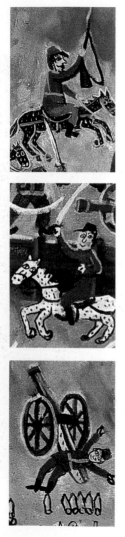

The other is to apprehend Naïve art as no more or less than that, and to look back into human prehistory and to a time when all art was of a type that might now be considered Naïve – tens of thousands of years ago, when the first rock drawings were etched and when the first cave-pictures of bears and other animals were scratched out.

The War of Independence
———————————————
Emil Pavelescu, 1877
Oil on canvas, 55 x 80 cm
Private collection

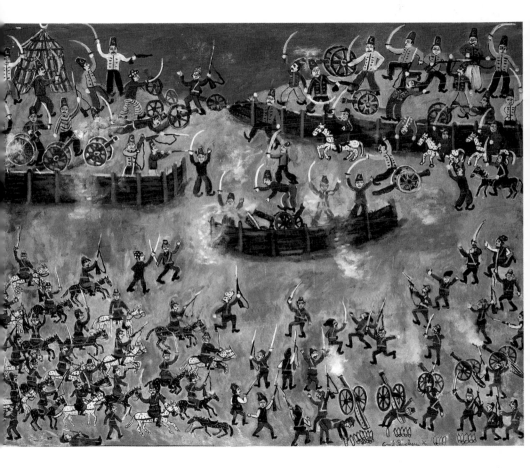

If we accept this second definition, we are inevitably confronted with the very intriguing question, 'So who was that first Naïve artist?' Many thousands of years ago, then, in the dawn of human awareness, there lived a hunter. One day it came to him to scratch on a smooth rock surface the contours of a deer or a goat in the act of running away.

Weaver Seen from front

Vincent van Gogh, 1884
Oil on canvas, 70 x 85 cm
Rijskmuseum, Amsterdam

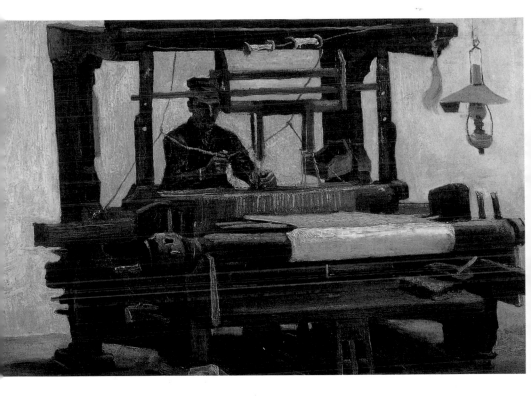

A single, economical line was enough to render the exquisite form of the graceful creature and the agile swiftness of its flight. The hunter's experience was not that of an artist, simply that of a hunter who had observed his 'model' all his life. It is impossible at this distance in time to know why he made his drawing. Perhaps it was an attempt to say something important to his family group;

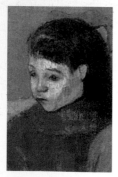

The Schuffenecker Family

Paul Gauguin, 1889
Oil on canvas, 73 x 92 cm
Musée d'Orsay, Paris

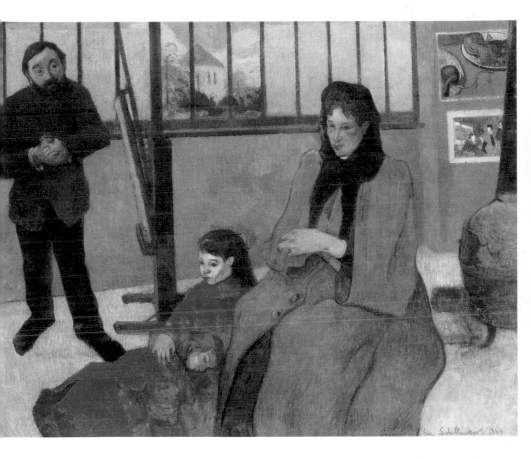

perhaps it was meant as a divine symbol, a charm intended to bring success in the hunt. From the point of view of an art historian, such an artistic form of expression testifies to an awakening of individual creative energy and a need, after its accumulation through the process of encounters with nature, to find an outlet for it.

Me, Landscape Portrait

Henri Rousseau, 1890
Oil on canvas, 143 x 110 cm
Narodni Gallery, Prague

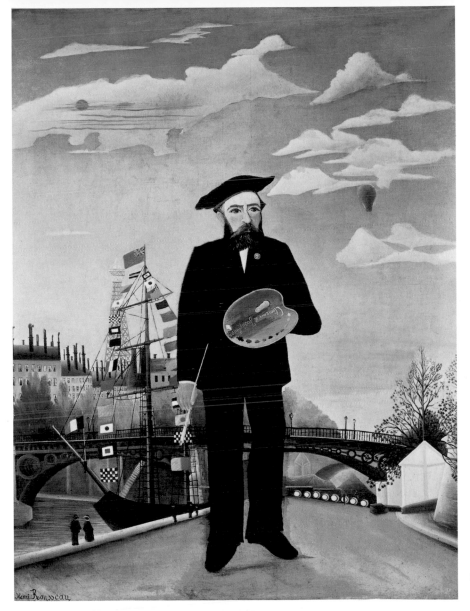

Henri Rousseau

This first-ever artist really did exist. He must have existed. And he must therefore have been truly 'naïve' in what he depicted because he was living at a time when no system of pictorial representation had been invented. Only thereafter did such a system gradually begin to take shape and develop. And only when such a system is in place can there be anything like a 'professional' artist.

Sign for a Wineshop

Niko Pirosmani
Oil on tin plate, 57 x 140 cm
Georgian Museum of Fine Arts, Tbilisi

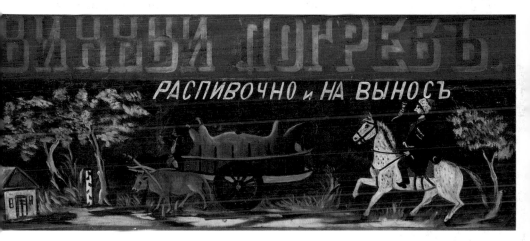

It is very unlikely, for example, that the paintings on the walls of the Altamira or Lascaux caves were creations of unskilled artists. The precision in depiction of the characteristic features of bison, especially their massive agility, the use of chiaroscuro, the overall beauty of the paintings with their subtleties of colorations – all these surely reveal the brilliant craftsmanship of the professional artist.

A Woman's Portrait

Henri Rousseau, 1895
Oil on canvas, 160 x 105 cm
Musée du Louvre, Paris

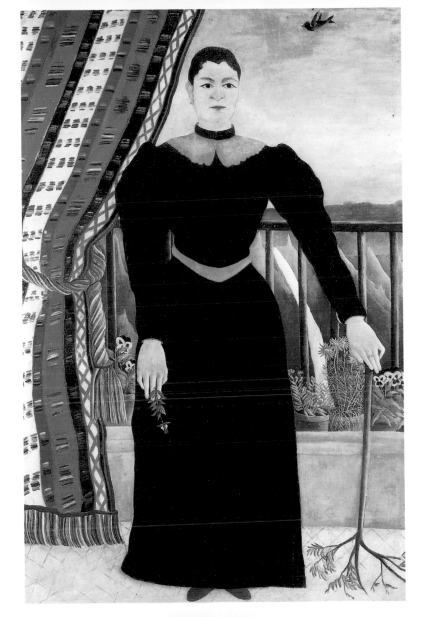

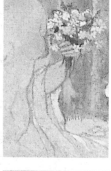

So what about the 'naïve' artist, that hunter who did not become professional? He probably carried on with his pictorial experimentation, using whatever materials came to hand; the people around him did not perceive him as an artist, and his efforts were pretty much ignored.

Faces in a Spring Landscape
(The Sacred Wood)
———————————
Maurice Denis, 1897
Oil on canvas, 94 x 120 cm
Pushkin Museum of Fine Arts, Moscow

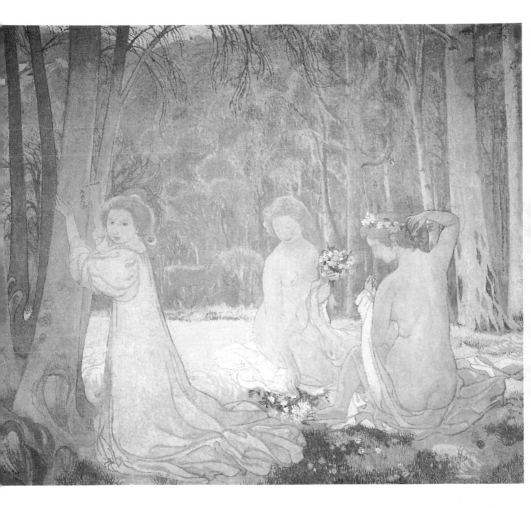

Any set system of pictorial representation – indeed, any systematic art mode – automatically becomes a standard against which to judge those who through inability or recalcitrance do not adhere to it. The nations of Europe have carefully preserved as many masterpieces of classical antiquity as they have been able to, and have scrupulously also consigned to history the names of the classical artists, architects, sculptors and designers.

The Girl with a Glass of Beer

Niko Pirosmani
Oil on canvas, 114 x 90 cm
Georgian Museum of Fine Arts, Tbilisi

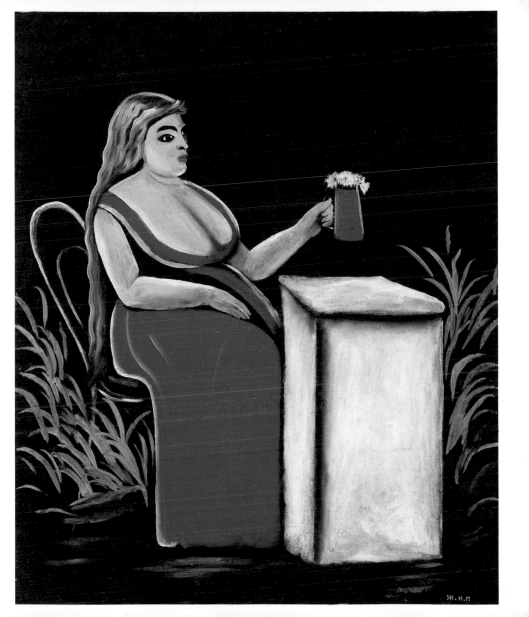

What chance was there, then, for some lesser mortal of the Athens of the fifth century BC who tried to paint a picture, that he might still be remembered today when most of the ancient frescoes have not survived and time has not preserved for us the easel-paintings of those legendary masters whose names have been immortalized through the written word?

Motherhood

Morris Hirshfield
Museum Charlotte Zander, Bönnigheim Castle

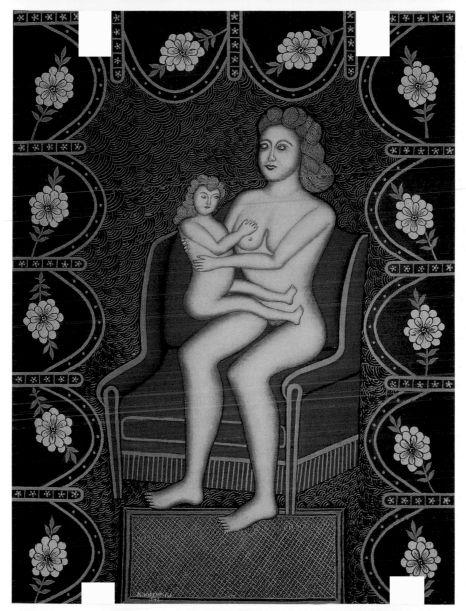

The name of the Henri Rousseau of classical Athens has been lost forever – but he undoubtedly existed. The Golden Section, the 'canon' of the (ideal proportions of the) human form as used by Polyclitus, the notion of 'harmony' based on mathematics to lend perfection to art – all of these derived from one island of ancient civilization adrift in a veritable sea of 'savage' peoples: that of the Greeks.

St George Slaughtering the Dragon

Anonymous painter, glass painting
Serbia, region of Vojvodina
Private collection, Italy

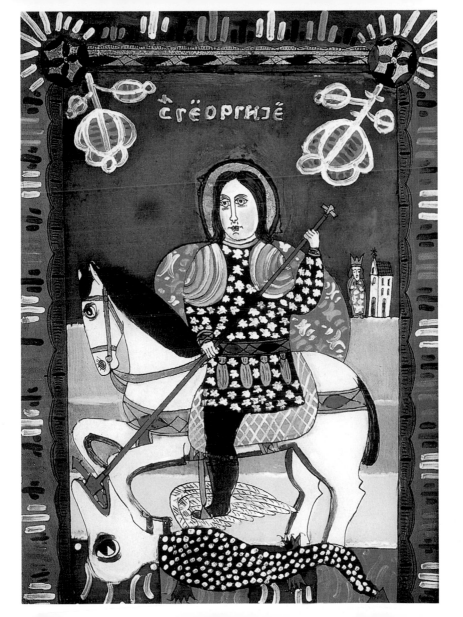

29

The Greeks encountered this tide of savagery everywhere they went. The stone statues of women executed by the Scythians in the area north of the Black Sea, for example, they regarded barbarian 'primitive' art and its sculptors as 'naïve' artists oblivious to the laws of harmony. As early as during the third century BC the influence of the 'barbarians' began to penetrate into Roman art, which at that time was largely derivative of Greek models.

St Martin's Gate

Louis Vivin
Oil on canvas, 50 x 61 cm
Museum Charlotte Zander, Bönnigheim Castle

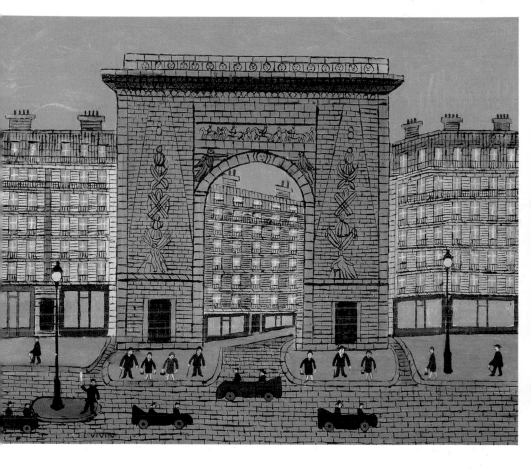

The Romans believed not only that they were the only truly civilized nation in the world but that it was their mission to civilize others out of their uncultured ways, to bring their primitive art forms closer to the rigorous standards of the classical art of the Empire. All the same, Roman sculptors felt free to interpret form in a 'barbaric' way, for instance by creating a sculpture so simple that it looked primitive and leaving the surface uneven and only lightly polished.

Still Life with Butterflies and Flowers

Louis Vivin
Oil on canvas, 61 x 50 cm
Museum Charlotte Zander, Bönnigheim Castle

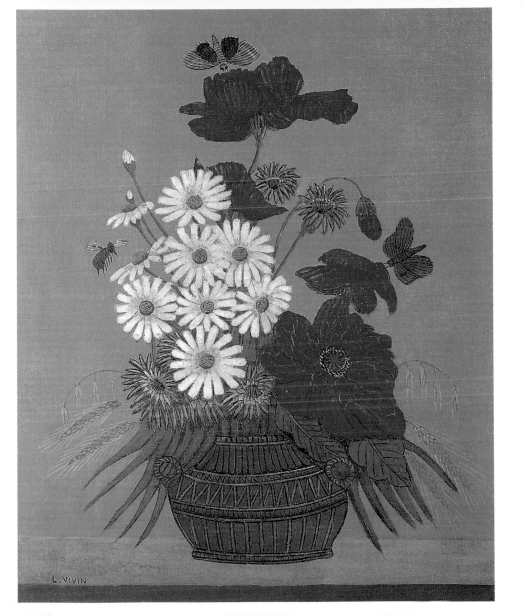

The result was ironically that the 'correct' classical art lacked that very impressiveness that was characteristic of the 'wrong' barbaric art. Having overthrown Rome's domination of most of Europe, the 'barbarians' dispensed with the classical system of art.

A Fruit Shop

Mikhail Larionov, 1904
Oil on canvas, 66 x 69 cm
Russian Museum, St Petersburg

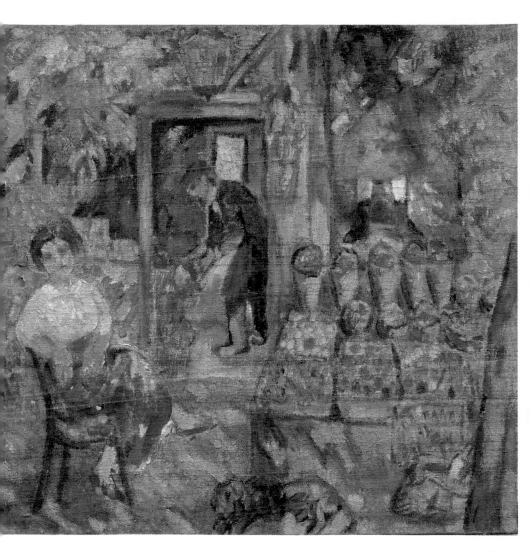

It was as if the 'canon' so notably realized by Polyclitus had never existed. Now art learned to frighten people, to induce a state of awe and trepidation by its expressiveness. Capitals in the medieval Romanesque cathedrals swarmed with strange creatures with short legs, tiny bodies and huge heads.

A Barn

Niko Pirosmani
Oil on cardboard, 72 x 100 cm
Georgian Museum of Fine Arts, Tbilisi

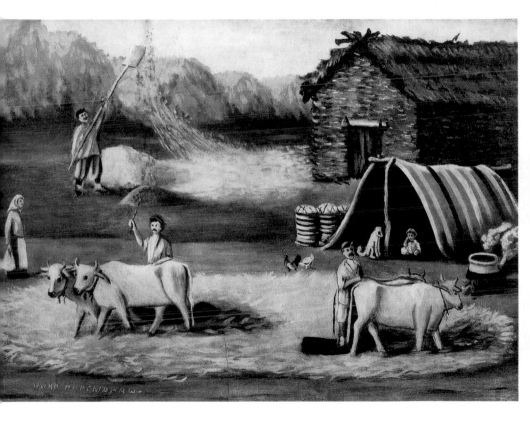

Who carved them? Very few of the creators' names are known. Undoubtedly, however, they were excellent artisans, virtuosi in working with stone. They were also true artists, or their work would not emanate such tremendous power. These artists came from that parallel world that had always existed, the world of what Europeans called 'primitive' art.

A Provincial Dandy
───────────────

Mikhail Larionov, 1907
Oil on canvas, 100 x 89 cm
Tretyakov Gallery, Moscow

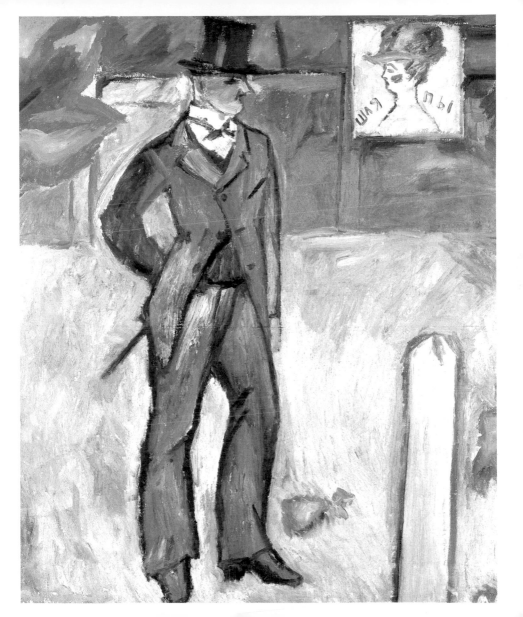

Reflections on Naïve Art

'Naïve' art, and the artists who created it, became well known in Europe at the beginning of the twentieth century. Who were these artists, and what was their background? To find out, we have to turn back the clock and look at the history of art at that time. It is interesting that for much of the intervening century, the Naïve artists themselves seem to

The Representatives of Foreign Powers
Coming to Greet the Republic as a Sign of Peace

Henri Rousseau, 1907
Oil on canvas, 130 x 161 cm
Musée Picasso, Paris

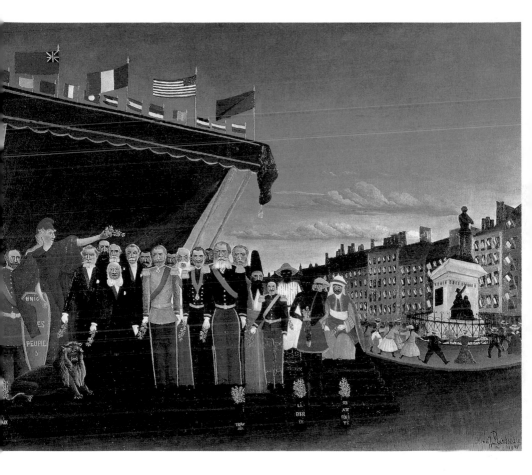

have attracted rather less attention than those people responsible for 'discovering' them or publicizing them. Yet that is not unusual. After all, the Naïve artists might never have come into the light of public scrutiny at all if it had not been for the fascination that other young European artists of the avant-garde movement had for their work – avant-garde artists whose own work has now,

View from the Bridge of Sèvres
and the Hills of Clamart and Bellevue

Henri Rousseau, 1908
Oil on canvas, 80 x 120 cm
Pushkin Museum of Fine Arts, Moscow

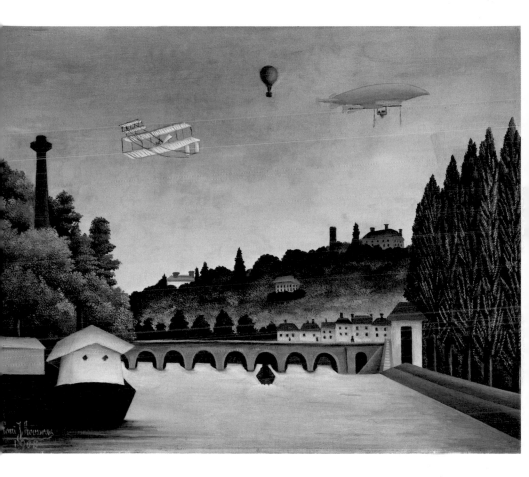

at the turn of the millennium, also passed into art history. In this way we should not consider viewing works by, say, Henri Rousseau, Niko Pirosmani, Ivan Generalic, André Bauchant or Louis Vivin without reference at the same time to the ideas and styles of such recognized masters as Pablo Picasso, Henri Matisse, Joan Miró, Max Ernst and Mikhail Larionov.

Father Juniet's Cart

———————

Henri Rousseau, 1908
Oil on canvas, 97 x 129 cm
Musée de l'Orangerie, Paris

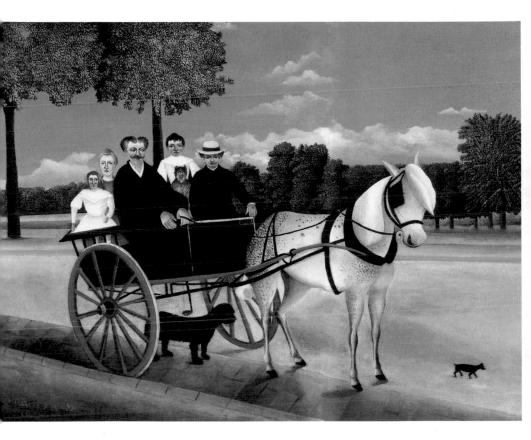

But of course, to make that reference itself presents problems. Who was influenced by whom, in what way, and what was the result? The work of the Naïve artists poses so many questions of this kind that experts will undoubtedly still be trying to unravel the answers for a good time yet.

In the Rain Forest

Henri Rousseau, 1908
Oil on canvas, 46 x 55 cm
The Hermitage, St Petersburg

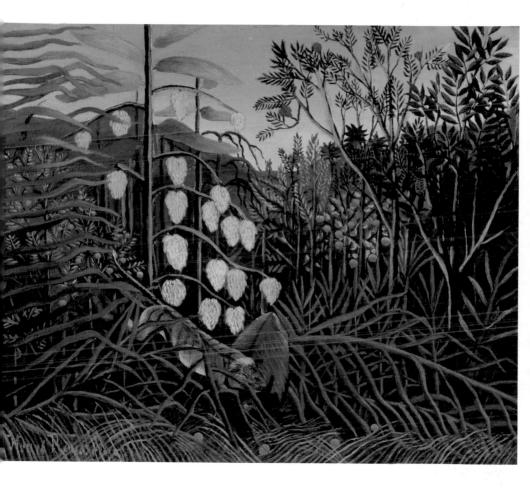

The main necessity is to establish for each of the Naïve artists precisely who or what the main source of their inspiration was. This has then to be located within a framework expressing the artist's relationship to the 'classic' academic ('official') art of the period. Difficult as it is to make headway in such research, matters are further complicated by

Guillaume Apollinaire and Marie Laurencin

Henri Rousseau, 1909
Oil on canvas, 200 x 389 cm
The Hermitage, St Petersburg

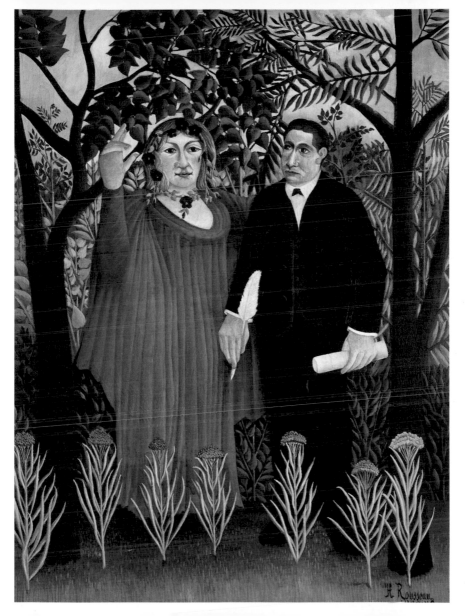

the fact that such questions may themselves have more than one answer – and that each answer may be subject to different interpretation by different experts anyway. It gets worse. All the time the works of previously unknown Naïve artists are coming to light, some of them from the early days of Naïve art, some of them relatively contemporary.

View on the Fortifications,
from the left of the Vanves Gate

Henri Rousseau, 1909
Oil on canvas, 31 x 41 cm
The Hermitage, St Petersburg

Their art may add to our understanding of the phenomenon of Naïve art or may change it altogether. For this reason alone it would simply not be feasible to come to an appreciation of Naïve art that was tightly-defined, complete and static.

The Spell

Henri Rousseau, 1909
Oil on canvas, 45.5 x 37.5 cm
Museum Charlotte Zander, Bönnigheim Castle

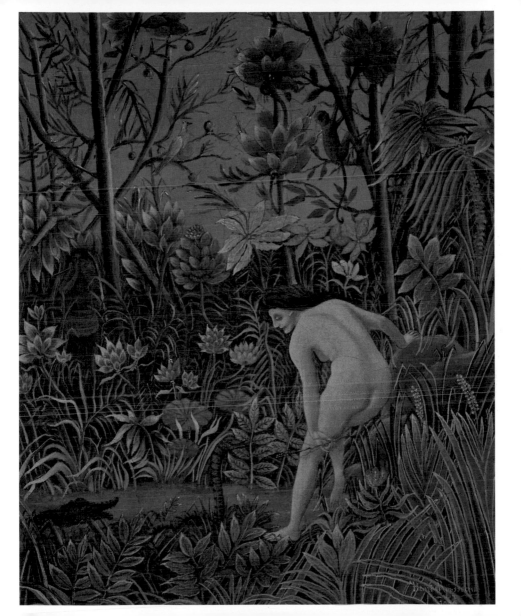

In this study, therefore, we will contemplate only those outstanding – yet outstandingly diverse – examples of Naïve art that really do constitute pointers towards a genuine style, a genuine direction in pictorial representation, albeit one that is currently little known. Think of this book, if you like, as a preliminary sketch for a picture that will be completed by future generations.

Romanian painting

It is difficult – perhaps even impossible – to quantify the influence of Henri Rousseau, Niko Pirosmani and Ivan Generalic on professional 'modern' artists and the artworks they produce. The reason is obvious: the three of them belonged to no one specific school and, indeed, worked to no specific system of art.

A Negro Attacked by a Panther

Henri Rousseau, ca. 1910
Oil on canvas, 114 x 162 cm
Museum of Arts, Basle

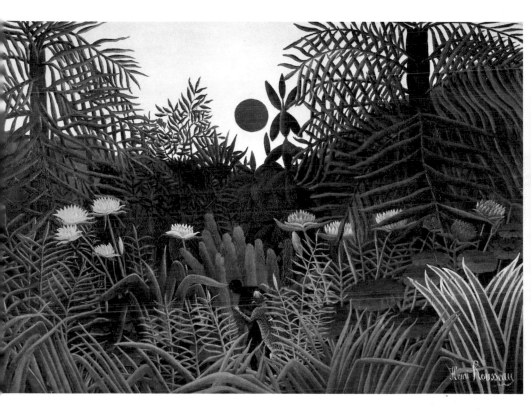

It is for this reason that genuine scholars of Naïve art are somewhat thin on the ground. After all, it is hard to find any basic element, any consistent factor that unites their art and enables it to be studied as a discrete phenomenon. The problems begin even in finding a proper name for this kind of art.

Notre-Dame-de-Paris

André Duranton

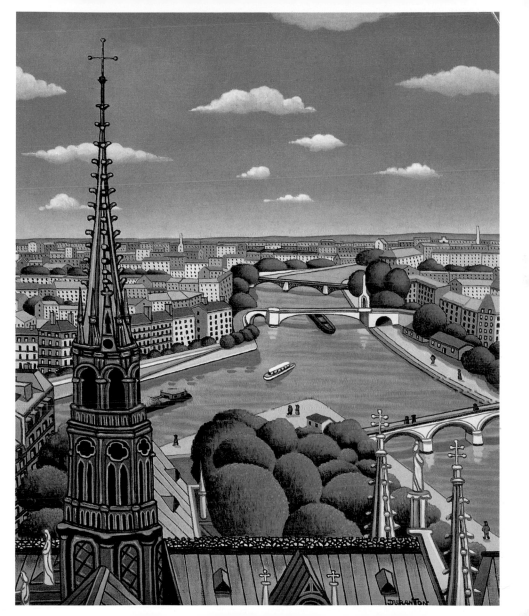

No single term is descriptive enough. It is all very well consulting dictionaries – they are not much use in this situation. A dictionary definition of a 'primitive' in relation to art, for example, might be 'An artist or sculptor of the period before the Renaissance'.

Horse Attacked by a Jaguar

Henri Rousseau, 1910
Oil on canvas, 89 x 116 cm
Pushkin Museum of Fine Arts, Moscow

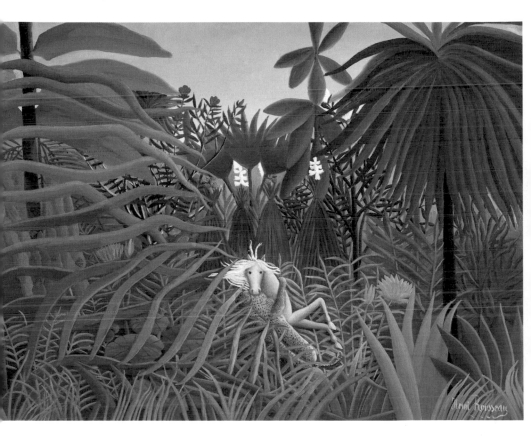

This definition is actually not unusual in dictionaries today – but it was first written in the nineteenth century and is now badly out of date because the concept of 'primitive' art has expanded to include the art of non-European cultures in addition to the art of Naïve artists worldwide.

A Walk in the Montsouris Park

Henri Rousseau, ca. 1910
Oil on canvas, 46.5 x 38.5 cm
Pushkin Museum of Fine Arts, Moscow

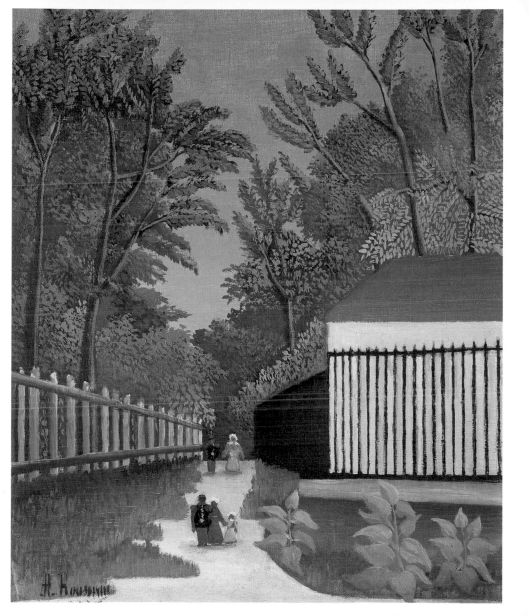

In incorporating such a massive diversity of elements, the term has thus taken on a broadness that renders it, as a definition, all too indefinite. The description 'primitive' is simply no longer precise enough to apply to the works of untaught artists.

Still Life

———

Niko Pirosmani
Oil on tin plate, 36 x 73 cm
Georgian Museum of Fine Arts, Tbilisi

The word 'Naïve', which implies natural-ness, innocence, unaffectedness, inexperience, trustfulness, artlessness and ingenuousness, has the kind of descriptively emotive ring to it that clearly reflects the spirit of such artists. But as a technical term it is open to confusion. Like Louis Aragon, we could say that 'It is naïve to consider this painting naïve.'

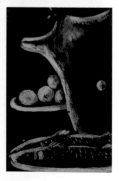

Still Life

Niko Pirosmani
Oil on tinplate, 36 x 73 cm
Georgian Museum of Fine Arts, Tbilisi

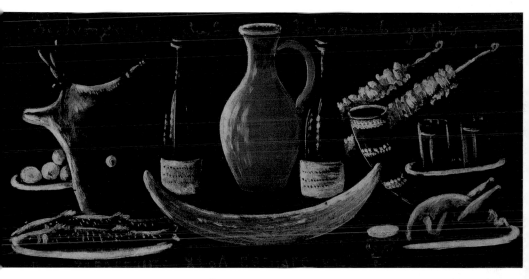

Many other descriptive expressions have been suggested to fill the gap. Wilhelm Uhde called the 1928 exhibition in Paris *Les Artistes du Sacré-Cœur*, apparently intending to emphasize not so much a location as the unspoiled, pure nature of the artists' dispositions. Another proposal was to call them 'instinctive artists' in reference to the intuitive aspects of their method.

The Grape-Pickers

Niko Pirosmani
Oil on canvas, 118 x 184 cm
Georgian Museum of Fine Arts, Tbilisi

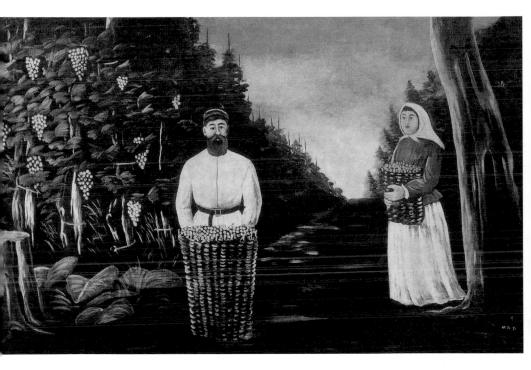

Yet another was 'neo-primitives' as a sort of reference to the idea of nineteenth-century style 'primitive' art while yet distinguishing them from it. A different faction picked up on Gustave Coquiot's observation in praise of Henri Rousseau's work and decided they should be known as 'Sunday artists'.

The Bego Company

Niko Pirosmani
Oil on canvas, 66 x 102 cm
Georgian Museum of Fine Arts, Tbilisi

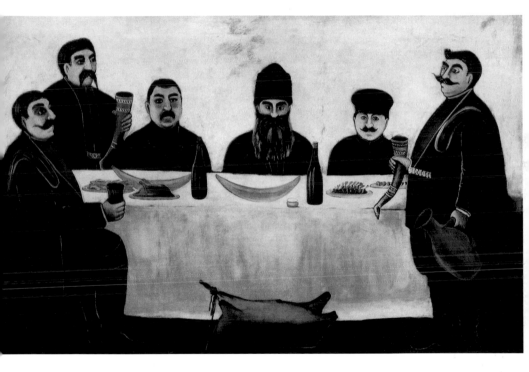

Of all the various terms on offer, it was 'Naïve' that won out. This is the word that is used in the titles of books and in the names of a growing number of museums. Presumably, it is the combination of moral and aesthetic factors in the work of Naïve artists that seems appropriate in the description.

... And with the Sergeant that Makes Ten

Ion Pencea
Oil on canvas, 50 x 55 cm
Private collection

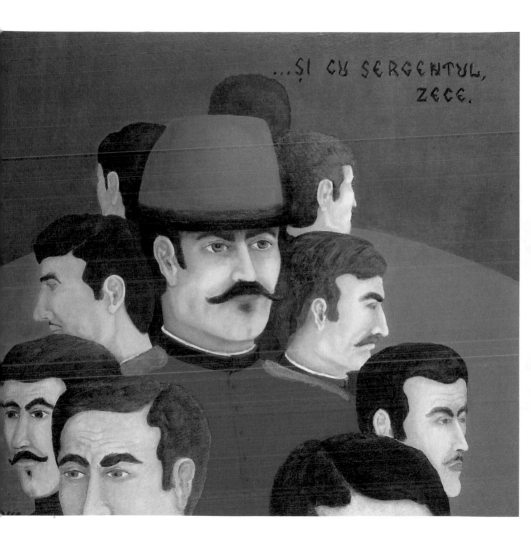

...ȘI CU SERGENTUL, ZECE.

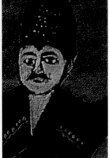

Gerd Claussnitzer alternatively believes that the term is meant pejoratively, as a nineteenth-century comment by the realist school on a visibly clumsy and unskilled style of painting. For all that, to an unsophisticated reader or viewer the term 'Naïve artist' does bring to mind an image of the artist as a very human sort of person.

The Wedding

Niko Pirosmani
Oil on canvas, 113 x 177 cm
National Museum of Oriental Art, Moscow

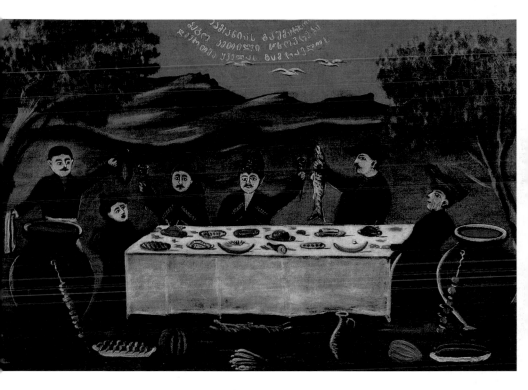

Every student of art feels a natural compulsion to try to classify the Naïve artists, to categorize them on the basis of some feature or features they have in common. The trouble with this is that the Naïve artists – as noted above – belong to no specific school of art and work to no specific system of expression.

A Bear in the Moonlight

Niko Pirosmani
Oil on oil-cloth, 100 x 80 cm
Georgian Museum of Fine Arts, Tbilisi

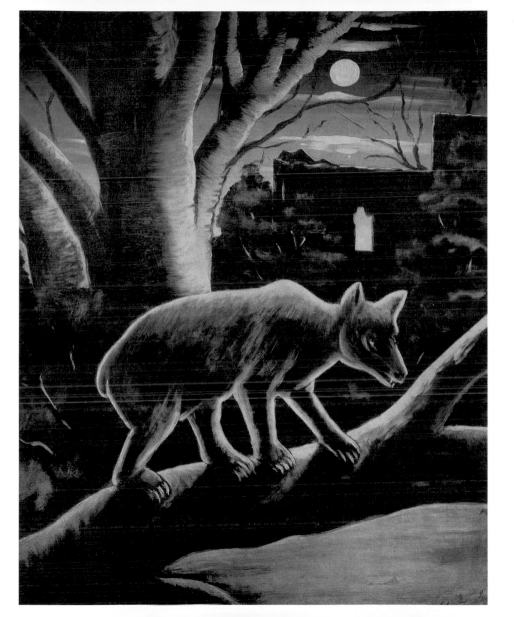

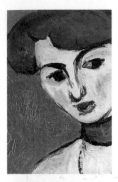

Which is precisely why professional artists are so attracted to their work. Summing up his long life, Maurice de Vlaminck wrote: 'I seem initially to have followed Fauvism, and then to have followed in Cézanne's footsteps. Whatever – I do not mind… as long as first of all I remained Vlaminck.'

Girl with Tulips
(Portrait of Jeanne Vaderin)

Henri Matisse, 1910
Signed and dated bottom left: Henri Matisse 10
Oil on canvas, 92 x 73,5 cm
The Hermitage, St Petersburg

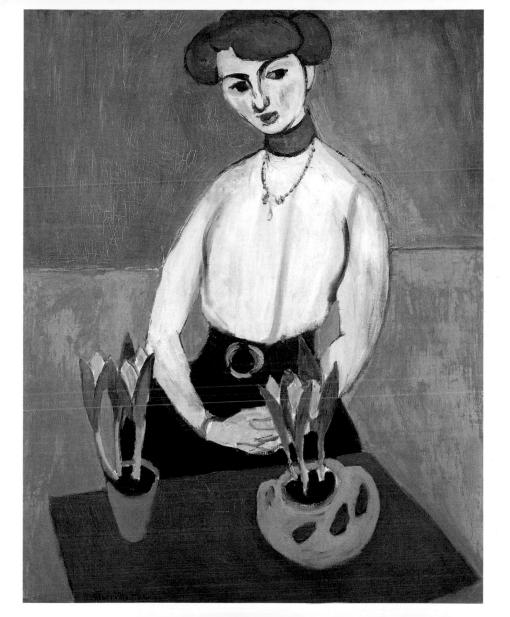

Naïve artists have been independent of other forms of art from the very beginning. It is their essential quality. Paradoxically, it is their independence that determines their similarity. They tend to use the same sort of themes and subjects; they tend to have much the same sort of outlook on life in general, which translates into much the same sort of painting style.

Goldfish

Henri Matisse, 1911
Oil on canvas, 147 x 98 cm
Pushkin Museum of Fine Arts, Moscow

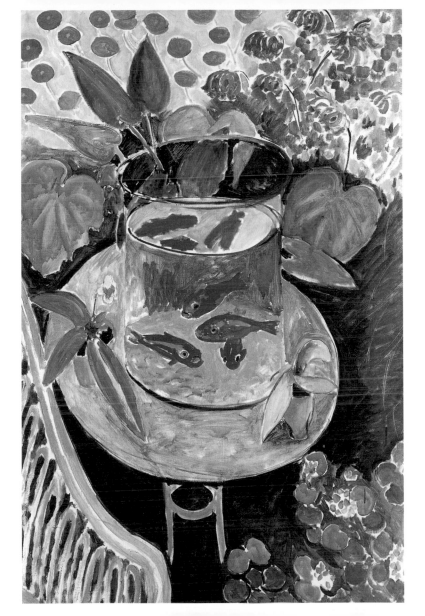

And this similarity primarily stems from the instinctual nature of their creative process. But this apart, almost all Naïve artists are or have been to some extent associated with one or other non-professional field of art. The most popular field of art for Naïve artists to date has been folk art.

A Waitress

Mikhail Larionov, 1911
Oil on canvas, 102 x 70 cm
Tretyakov Gallery, Moscow

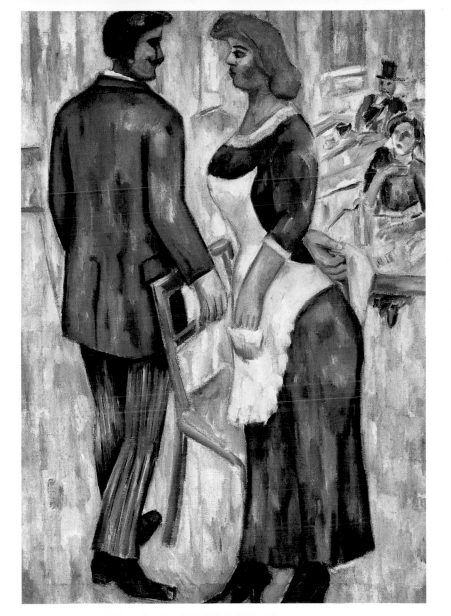

From Popular Tradition to Photography
Naïve Artists and Folk Art

A Naïve artist creates singular and inimitable works of art. This is because, for the most part, the Naïve artist is not a professional artist but has a quite separate occupation by which he or she earns a living, in which he or she relies on a totally different set of skills (in which he or she may be expert enough to achieve considerable job satisfaction), and which takes

Notre-Dame under Snow

Michel Delacroix
Oil on canvas, 82 x 60 cm
International Museum of Naïve Art, Vicq

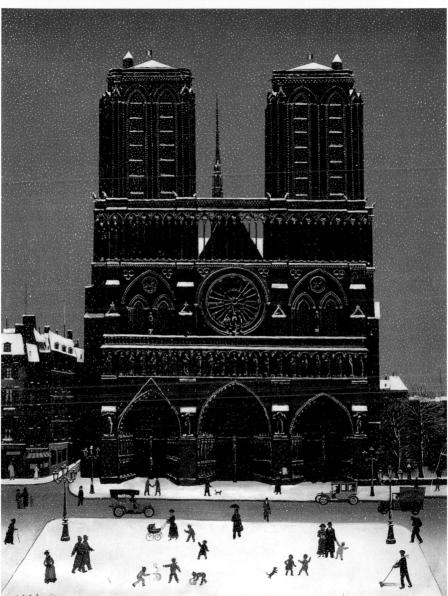

Michel Delacroix

up much of his or her daily life. The twentieth century has seen many a 'Sunday artist' who has attracted imitators and patrons but who has never ceased to look at the world through the eyes of his or her workaday occupation. Particularly characteristic of them is an artisan's diligence and pride in the works of art they produce.

A Lamb and a Laden Easter Table
with Angels in the Background

Niko Pirosmani
Oil on oil-cloth, 80 x 100 cm
Georgian Museum of Fine Arts, Tbilisi

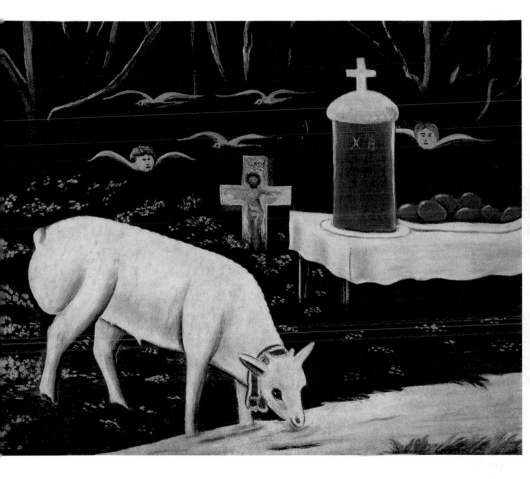

They take their 'professional' attitude towards their workaday occupation and transfer it on to their creations. They have no access to elite artistic circles, and would not be accepted by them if they had. The Naïve artists thus live in a small world, often a provincial world, a world that has its own artisans – the producers of folk art.

Portrait of Ilya Zdanevitch

Niko Pirosmani, 1913
Oil on cardboard, 150 x 120 cm
The Schuster collection, St Petersburg

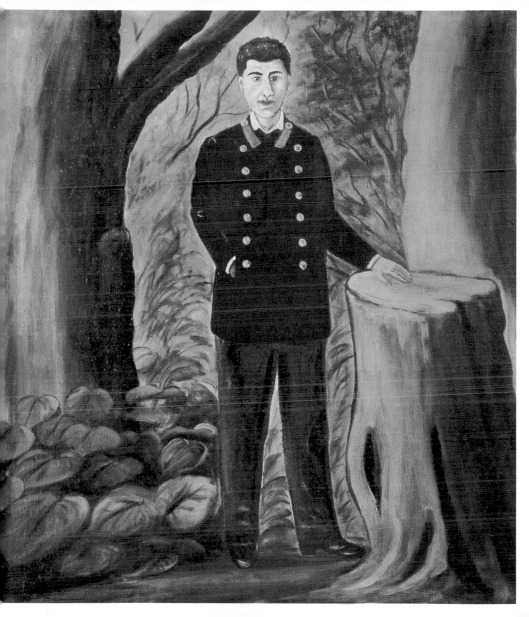

Some say that folk artists have for centuries repeated the same forms using the same colours in the same style, and are doomed therefore endlessly to reproduce the same subjects in their art and to the same standards. But folk artists do not only produce traditional forms of applied art – they also make shop-signs and colourfully ornate panels for stalls and rides at fairs.

At Table

Natalia Gontcharova, 1914
Sketch for the unmade curtain
of the Rimsky-Korsakov's opera

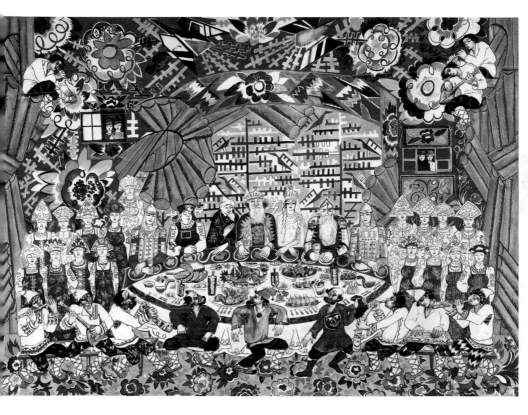

And although these artisans' work is rooted in their own form of expertise, it is often very difficult to draw a distinct line to separate their work from that of Naïve artists. Sometimes, after all, the power in the colorations, the sense of modernity and the feel for line and form in an artisan-made sign can elevate it to the level of an outstanding and individual work of art.

Military Popular Print

Kasimir Malevitch, 1914
lithograph in colour, 33.7 x 56 cm
Russian Museum, St Petersburg

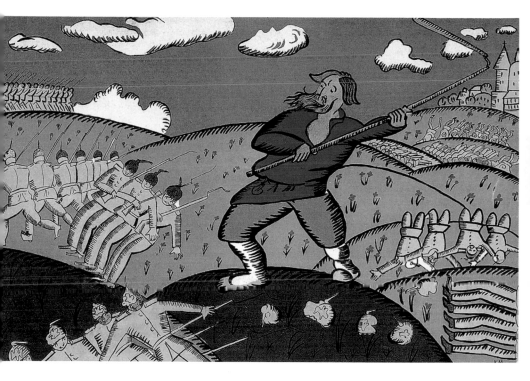

At the same time it should be remembered that when Henri Rousseau or Niko Pirosmani painted a restaurant sign or was commissioned by neighbours to depict a wedding in their house or their new cart in the barn, the resulting piece would be considered by all to be artisans' work.

Venus and Mikhail

Mikhail Larionov, 1912
Oil on canvas, 68 x 85.5 cm
Russian Museum, St Petersburg

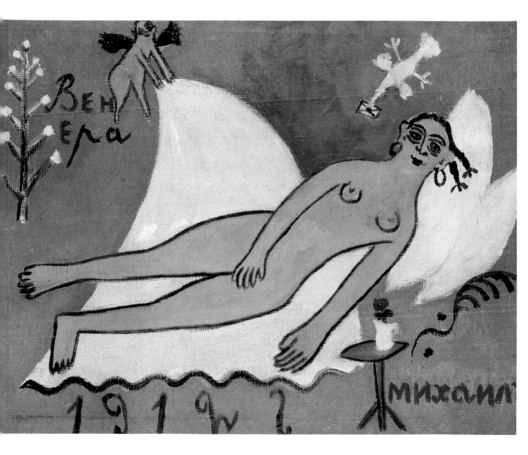

In Russia, the painted sign has always enjoyed a special status, and those who are exceptionally talented at producing them deserve recognition as genuine Naïve artists. 'A sign in Russia has no equivalent in Western cultures,' wrote the artist David Burliuk in 1913.

Woman with Flowers and an Umbrella

Niko Pirosmani
Oil on oil-cloth, 111 x 52 cm
Georgian Museum of Fine Arts, Tbilisi

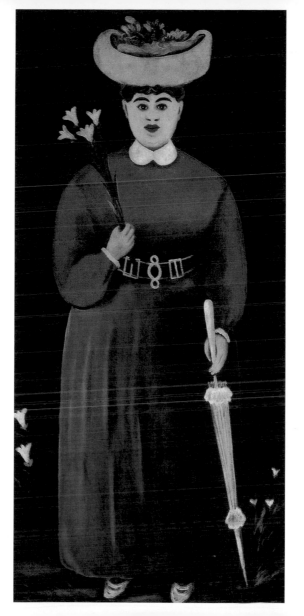

'The utter illiteracy of our people [and he was being quite serious at the time] has made it an absolute necessity as a means of communication between shopkeeper and customer. In the Russian sign the folk genius for painting has found its only outlet.'

A Fisherman

Niko Pirosmani
Oil on oil-cloth, 113 x 93 cm
Georgian Museum of Fine Arts, Tbilisi

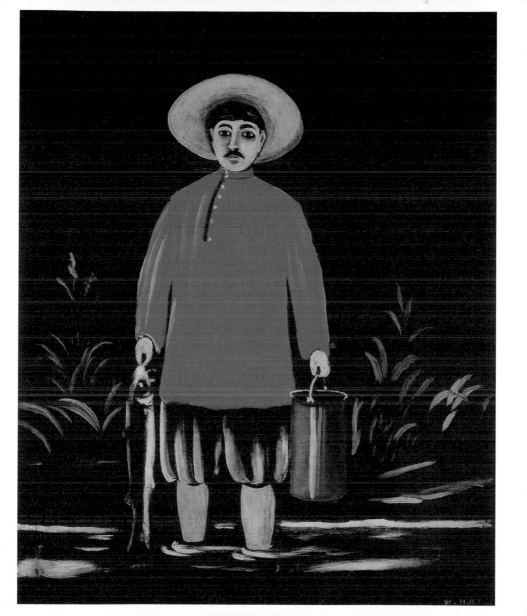

A multitude of bylaws and regulations governed the size and shape and even the look of signs in urban environments. It was the inventive capacity of the creators that helped them find a way through the maze of restrictions.

A Woman Milking a Cow

Niko Pirosmani, 1916
Oil on cardboard, 81 x 100 cm
Georgian Museum of Fine Arts, Tbilisi

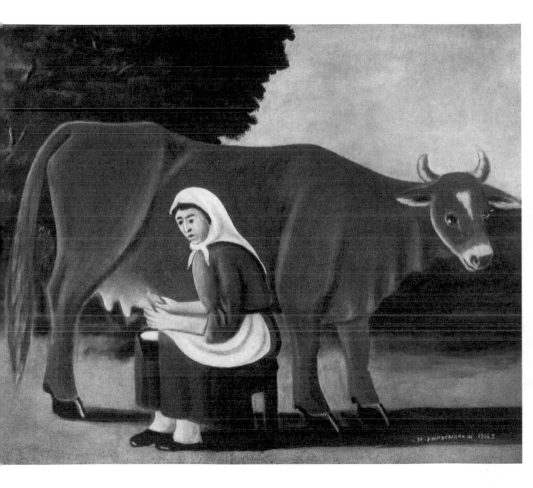

By the end of the nineteenth century the best of the sign-painters were putting their names to their works: one or two were even making a reputation for themselves. At the turn of the twentieth century one name that became well known in St Petersburg in this way was that of Konstantin Grushin.

Bathing a Baby
———————

Marc Chagall, 1916
Tempera on cardboard, 59 x 61 cm
Art and Architecture History Museum, Pskov

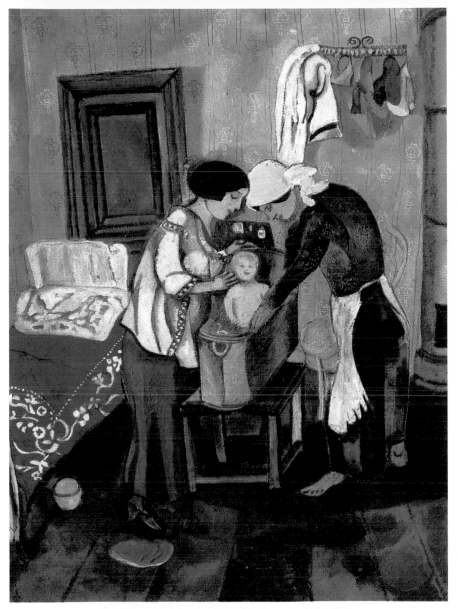

His work on behalf of the shopkeepers of the city included magnificent still lifes of fruit and vegetables, and picturesque landscapes with bulls or birds. Signs were supposed to be painted against a black border. Despite this regulation, the painter Yevfimiy Ivanov managed to produce works of art that truly befitted such a description.

A Tavern in Moscow

Boris Kustodiev, 1916
Oil on canvas, 99.3 x 129.3 cm
Tretyakov Gallery, Moscow

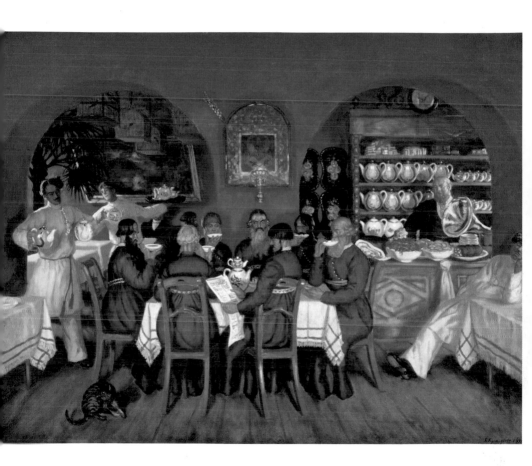

His style was free and broad, his composition uninhibited yet expert. Notwithstanding the fact that the functional nature of signs imposed upon them a certain need for a quality of flatness and ornamentation, each artist dealt with this requirement in his or her own way.

Imatra

———

Vassily Kandinsky, 1917
Watercolour on paper, 22.9 x 28.9 cm
Pushkin Museum of Fine Arts, Moscow

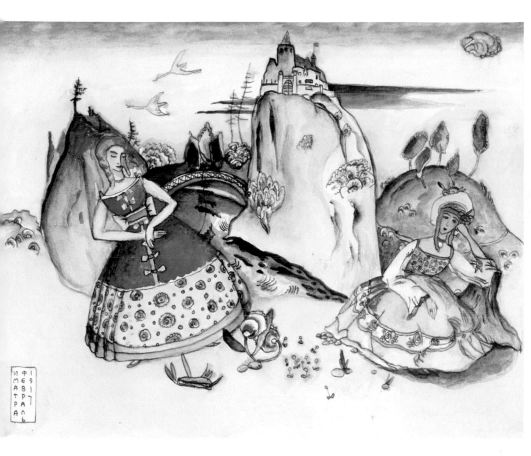

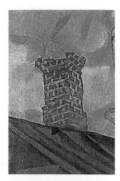

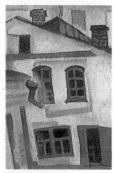

A panel meant to advertise Shabarshin's Furniture Delivery Services, for example, painted by the talented Konstantin Filippov, may be called a sign only because there are words on it. In all other respects it is an easel-painting. Powerfully-portrayed draught-horses are set against a delicately refined backdrop.

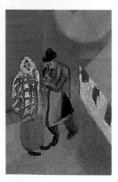

The Market Place

Marc Chagall, 1917
Oil on canvas, 66.3 x 97 cm
Metropolitan Museum of Art, New York

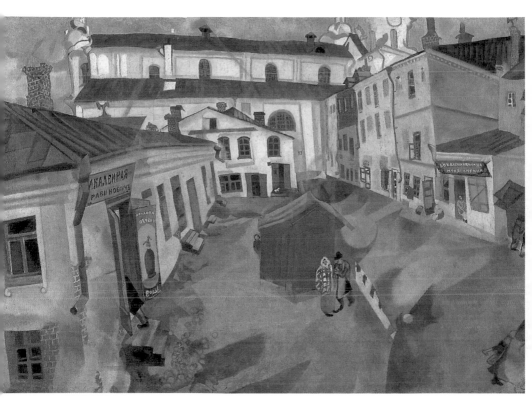

The wheels and harnesses of the horses are meticulously executed. In overall style this work is typical of urban Naïve artists, reminiscent of The famous *Father Juniet 's Cart* by Henri Rousseau. Ready-to-wear clothes shops were particularly blessed in the quality of their signs.

A Deer Family
───────────────

Niko Pirosmani, 1917
Oil on cardboard, 95 x 145 cm
Collection of the Grammeleki family, Tbilisi

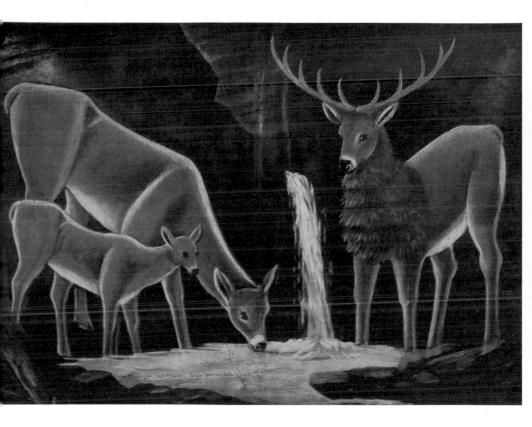

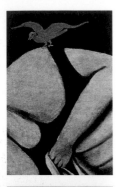

Vasily Stepanov's advertising signs for the shops of a certain Mr Kuzmin featured fashionably-dressed ladies and gentlemen, but he made them look as if they had been asked to sit for ceremonial portraits, virtually in salon style. Stepanov did, however, include some elements of parody.

The Beauty of Ortatchal

Niko Pirosmani, diptych 1 and 2
Oil on canvas, 52 x 117 cm
Georgian Museum of Fine Arts, Tbilisi

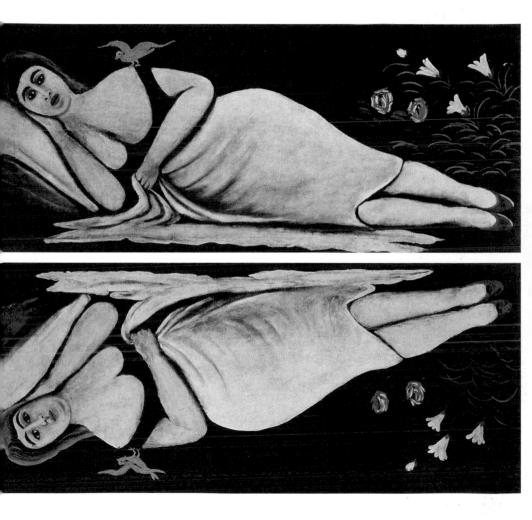

Singular in themselves and yet typical of their kind, these signs were supremely representative of their time and location, and as such constitute a sort of historical document. It was no wonder that signs like these were prized so highly by the artists of the Russian avant-garde (the artists of Picasso's generation) that they started to collect them.

A Girl at Hairdresser's

Mikhail Larionov, 1920's
Oil on canvas, 159 x 152 cm
From the former collection of Tomilia Larionova, Paris

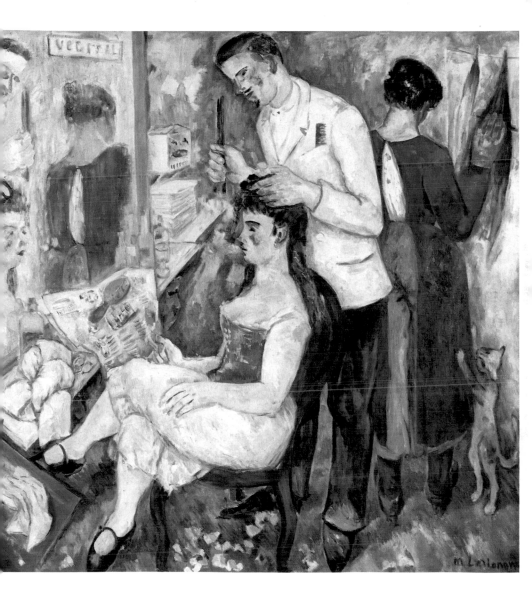

M Lalianov

The poet Benedikt Livshitz wrote, 'A burning desire for things primitive, and especially for the signs painted to advertise provincial establishments of such trades as laundry, hairdressing, and so on – as had had a profound effect on Larionov, Goncharova and Chagall – caused Burliuk to spend all the

The Actress Marguerite

Niko Pirosmani
Oil on canvas, 117 x 94 cm
Georgian Museum of Fine Arts, Tbilisi

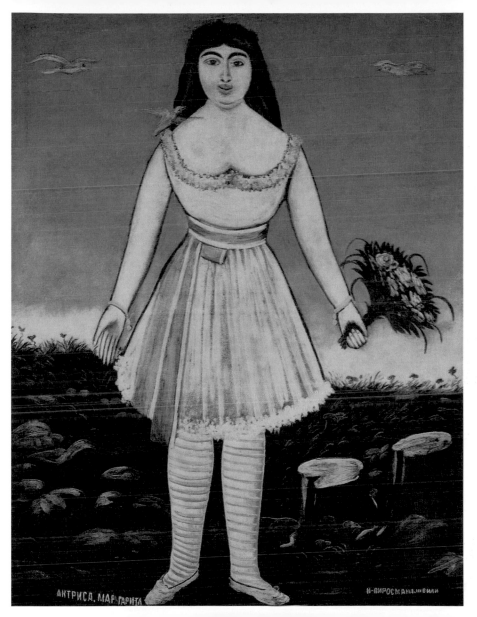

АКТРИСА. МАРГАРИТА Н-ПИРОСМАНАШВИЛИ

money he had on buying signs created by artisans...For Burliuk it was not simply a matter of satiating a temporary whim involving a fad for folk art, a sudden craze for the primitive in all its manifestations, such as the art of Polynesia or ancient Mexico. No, this enthusiasm was far more profound.' Reflecting on the origins of the interest of the avant-garde in primitive art as a whole,

Mother and Child with a Bunch of Flowers

André Bauchant, 1922
Oil on canvas, 72.3 x 58.5 cm
Museum Charlotte Zander, Bönnigheim Castle

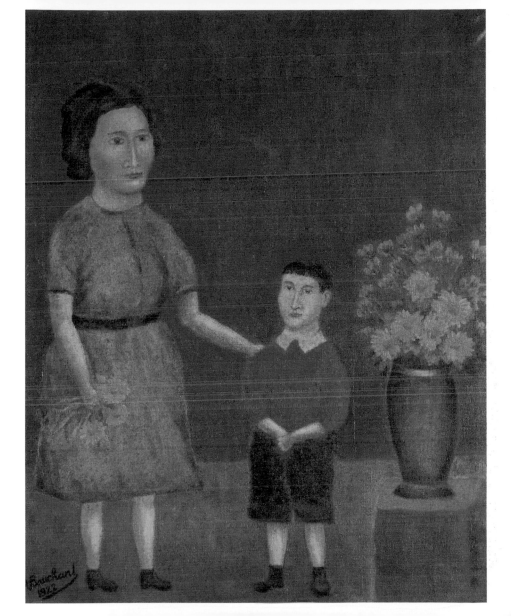

Livshitz quoted an eloquent statement by the brothers David and Vladimir Burliuk. 'There has been no progress whatsoever in art – has been none, and never will be any! Etruscan statues of the gods are in no way inferior to those of [the ancient Athenian] Phidias. Each era has the right to believe that it initiates a Renaissance.'

Still Life with Rabbit

André Bauchant, 1924
Oil on canvas, 100 x 67 cm
Museum Charlotte Zander, Bönnigheim Castle

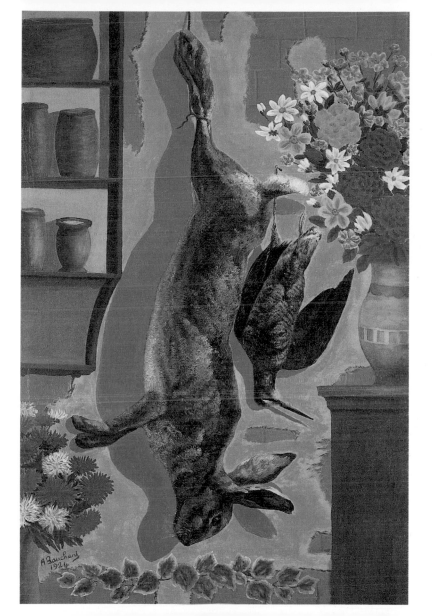

Historical circumstances delayed the onset of the industrial revolution in Russia. The chaos that surrounded the political Revolution hindered the authorities from re-establishing order in urban centres for some considerable time.

Bunch of Flowers in a Landscape

André Bauchant, 1926
Oil on canvas, 100 x 67 cm
Museum Charlotte Zander, Bönnigheim Castle

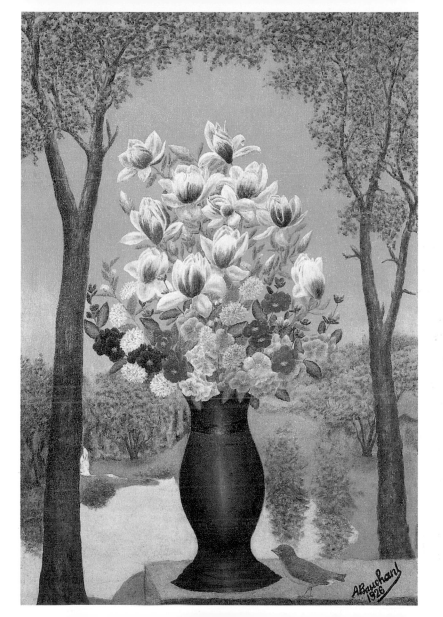

Nevertheless, the production of the traditional shop-signs continued for a while not only in rural areas but also in St Petersburg and in Moscow. The German philosopher and diarist Walter Benjamin, who endeavoured to create a written 'portrait' of contemporary Moscow, inscribed in his diary on 13 December 1926, 'Here, just as in Riga, they

Bouquet

Séraphine Louis, ca. 1927-1928
Oil on canvas, 117 x 89 cm
Museum Charlotte Zander, Bönnigheim Castle

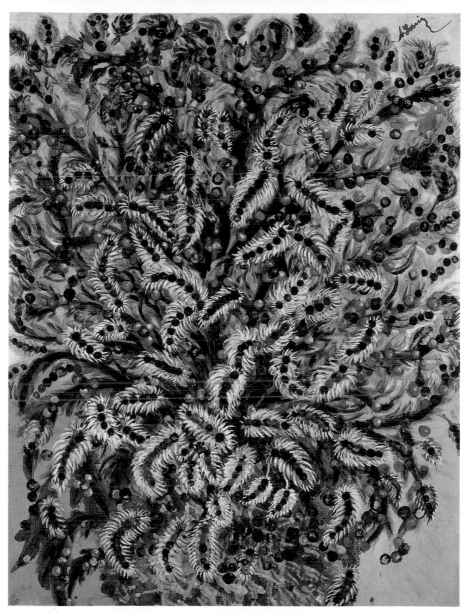

have wonderful painted signs – shoes falling out of a basket, a Pomeranian [Spitz dog] running off with a sandal between his jaws. In front of one Turkish restaurant there are two signs set like a diptych featuring a picture of gentlemen wearing fezzes with crescents on them sitting at a laid table.'

An Old Mansion in Périgueux

Camille Bombois, ca. 1928
Oil on canvas, 100 x 81 cm
Museum Charlotte Zander, Bönnigheim Castle

Painted shop-signs eventually disappeared. They became unnecessary, too expensive in time and cost, thanks to the arrival of the machine-dominated world in which everything could be produced mechanically, and where there was no place left in the severely insensitive urban environment for Naïve art that came from the heart.

Love and Flowers

André Bauchant, 1929
Oil on canvas, 174 x 109 cm
Museum Charlotte Zander, Bönnigheim Castle

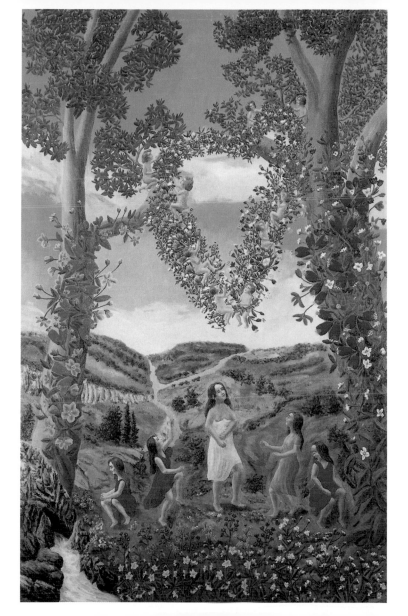

During the decades of the Soviet Union, some Naïve artists continued to paint privately, deep within a closed family circle involving only family members and trusted neighbours who went on thinking of them as artists.

At the Brothel

Camille Bombois, ca. 1930
Oil on canvas, 46 x 55 cm
Museum Charlotte Zander, Bönnigheim Castle

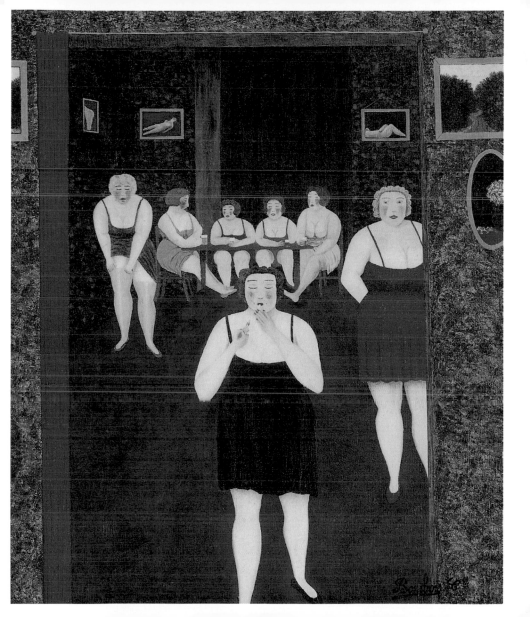

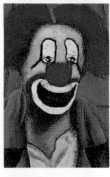

Others joined the numerous art studios, so leaving the ranks of the Naïve while yet not being accepted into the ranks of the professional artists. The popular Russian magazine, *Ogonyok*, has from time to time included prints of works of art by 'ordinary people'. In 1987 its readers were introduced to the pictures of Yelena Volkova.

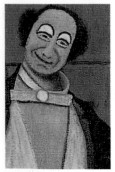

Mario, Fratellino and little Walter

Camille Bombois
Oil on canvas, 65 x 50 cm
Museum Charlotte Zander, Bönnigheim Castle

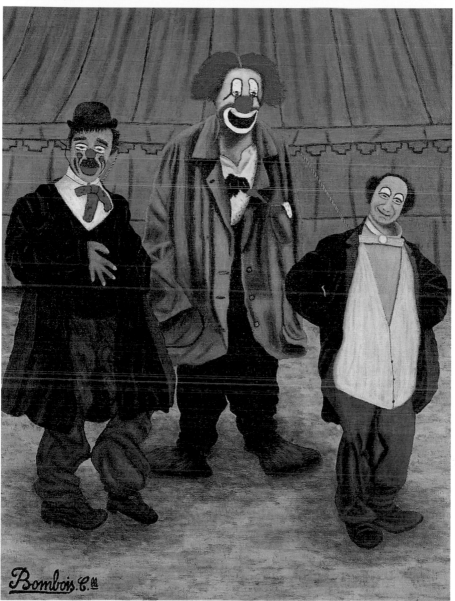

Bombois. C.^{ie}

Brought up on an island not far from the Ukrainian city of Chuguyev, she tended to concentrate on painting riverside trees with bright green foliage, other scenes featuring people and animals, and equally colourful still lifes.

The Athlete

Camille Bombois, ca. 1930
Oil on canvas, 130 x 89 cm
Museum of Modern Art, Pompidou Centre, Paris

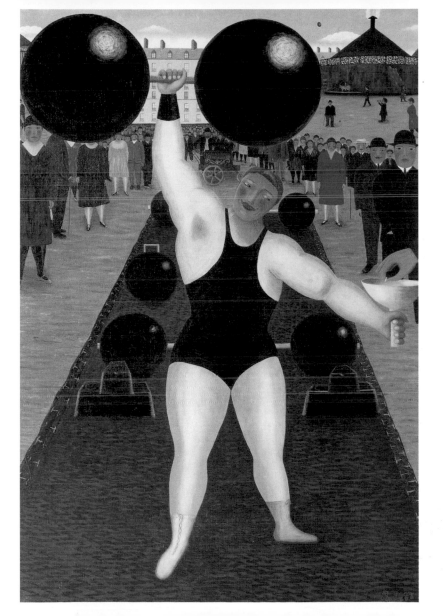

The disparate elements of everyday existence combine in Volkova's art to produce works that have much of the idyllic in them – a trait characteristic of many (and quite possibly all) Naïve artists. A generally happy world is painted to portray that happiness, only in a brighter, richer, yet more serene way.

At the Bar

Camille Bombois
Oil on canvas, 55 x 46 cm
Museum Charlotte Zander, Bönnigheim Castle

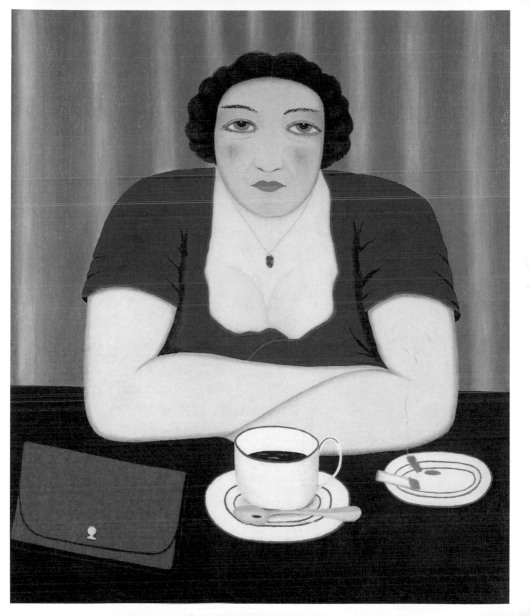

Yelena Volkova came to painting at a mature age, but her creative imagination draws on her childhood memories, particularly those filled with the dazzling colours of the village fairs. Folk crafts were still blossoming in Russia in those days.

Nude

———

Camille Bombois

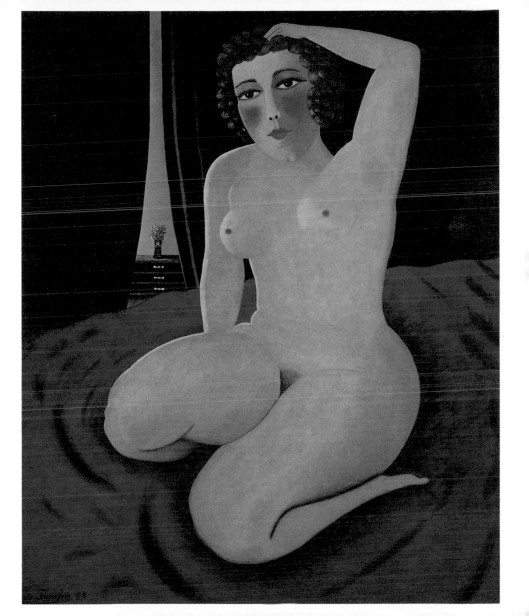

Pottery, lacework, wooden toys and household articles, and so forth, were an integral part of ordinary rural life. Unhappily, today many of these traditions have been irretrievably lost. Yet aesthetic notions that derive from them continue to have some influence not only in rural districts but in urban areas too.

A Naked Woman Sitting

Camille Bombois, ca. 1936
Oil on canvas, 100 x 81 cm
Museum Charlotte Zander, Bönnigheim Castle

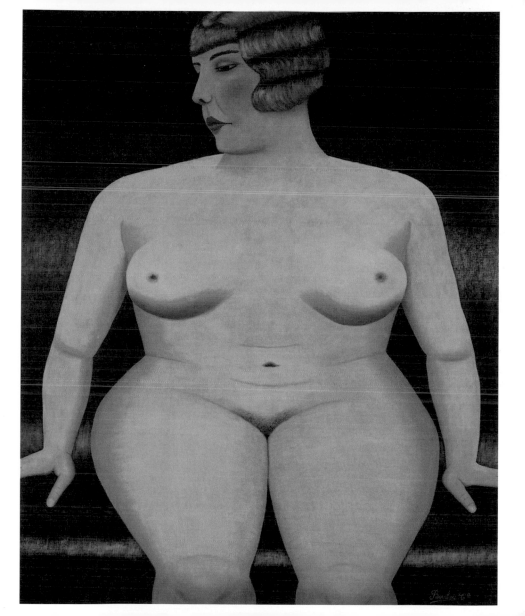

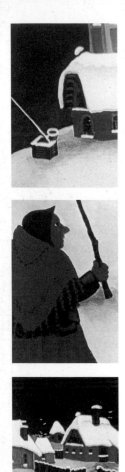

Eccentric personages who have a driving passion for painting pictures in their spare time should not automatically be associated with folk arts and crafts, however. On the contrary, such an association remains relatively rare by the end of the twentieth century.

The Shepherd and the Flock

Ivan Generalic

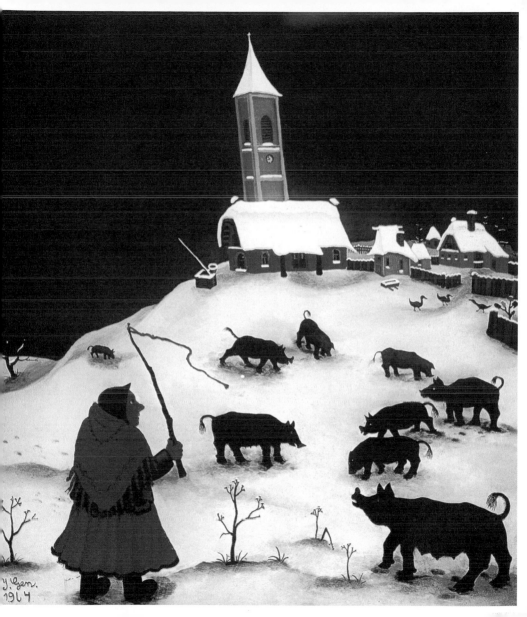

For one thing, whatever the conscious intentions of Naïve artists are when they create their works of art, it is their own interests – their own choice of subject matter and presentation – that they are realizing. In that respect, such interests, influenced, for instance by the kitsch environment of a city market, remain the same no matter what or where the city is, no matter even if the city is Paris and the

In the Meadow

Ivan Generalic

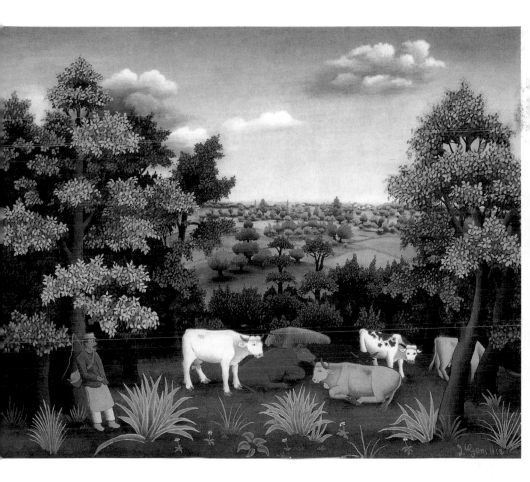

artists regularly visit the Louvre. But where this association between Naïve art and folk art has been established in an artist, is it possible to distinguish the different elements in the artist's work, to differentiate between the art of Naïve art and the kitsch of the city-market folk art?

The Christening of the Ship

Maria Palatini

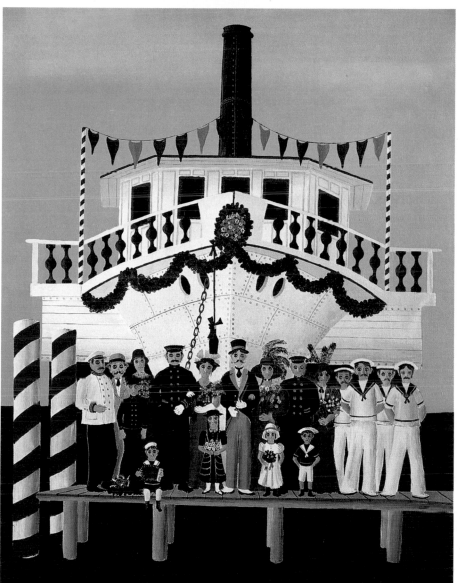

National characteristics manifest themselves in a much more powerful way in the sort of Naïve art that is closely associated with folk art than in the unified classical system of art. Their presence is more evident where such an association remains intimate, most often in the work of rural artists, and less evident in the sanitized environment of a big city.

Fishing

Alexandrina Lupascu
Oil on card, 32 x 45 cm
Private collection

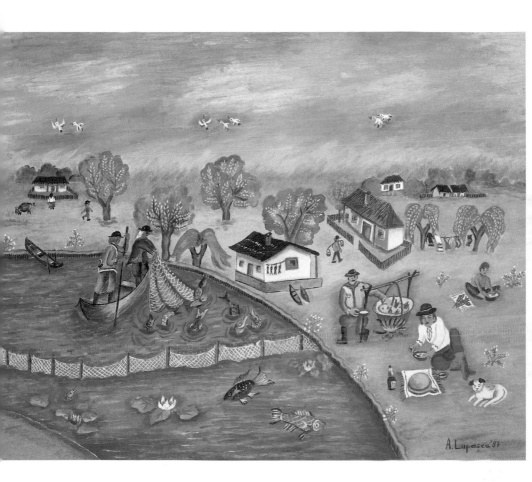

Anatoly Yakovsky has suggested that a fondness for folk art is more noticeable in a country that has undergone a sudden transition from the era of the artisan to the age of the modern industrial complex. This would explain how it is that in some of the Latin American countries, for instance, or in Haiti,

The Clowns

Paula Jacob
Oil on canvas, 50 x 40 cm
Private collection

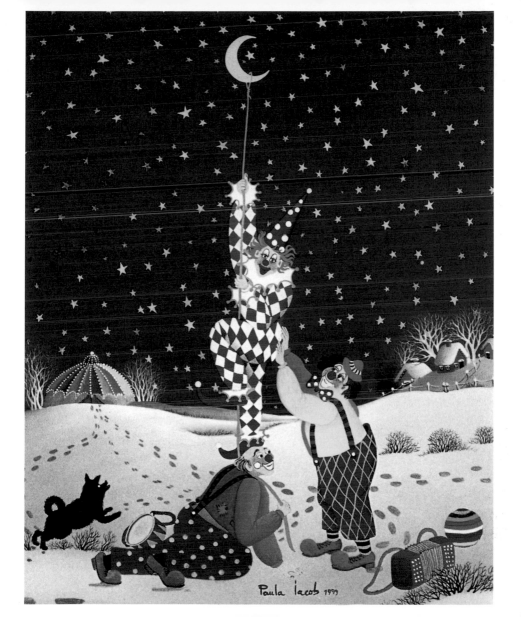

Paula Iacob 1999

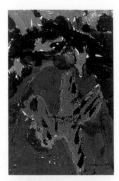

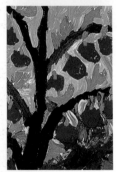

where there has been a synthesis of a darkly pagan religion with no less primitive forms of Christianity, enthusiasts have searched for and found Naïve paintings of outstanding quality. The works of the Brazilian and Haitian Naïve artists retain an essentially Brazilian or Haitian feel to them because their connection with the assorted influences of local religions and crafts has not yet loosened.

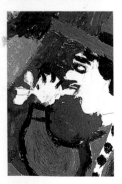

Making One's Farewells

Ana Kiss
Oil on card, 42 x 53 cm
Private collection

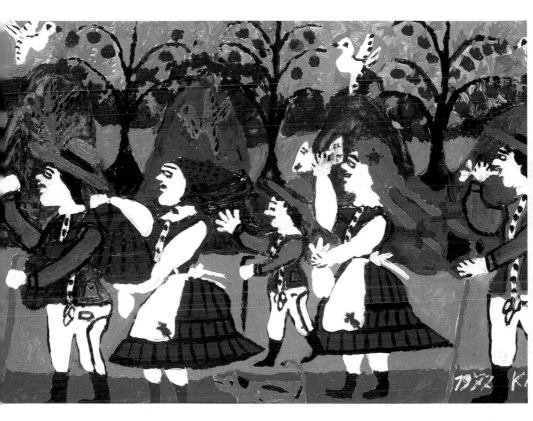

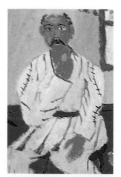

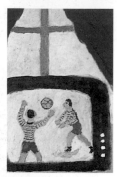

Back at that threshold between the nineteenth and the twentieth centuries, Russia was in the process of becoming an industrial power in Europe, yet its virtually medieval artistic craftsmanship remained pretty well unchanged. The diarist Walter Benjamin (quoted above) was astounded by the multicoloured diversity of life on the Moscow streets:

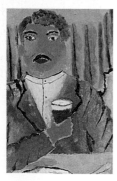

Country Folk at Table, Yesterday and Today

Gheorghe Mitrachita
Oil on canvas, 50 x 60 cm
Private collection

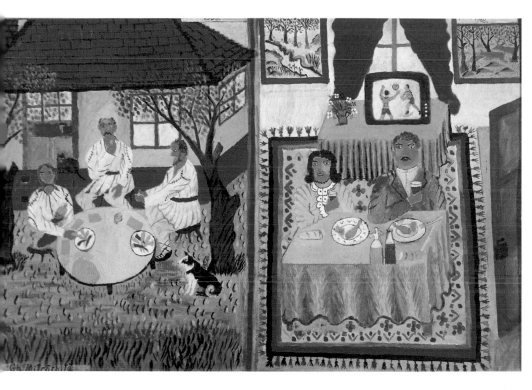

'Women – dealers and peasant – farmers – set up their baskets with their wares in front of them... The baskets are full of apples, sweets, nuts, sugary confections... It is still possible here to find people whose baskets contain wooden toys, small carts and spades. The carts are yellow and red, the spades are yellow or red... All the toys are simpler and more robust than in Germany – their rustic origins are very plain to see. On one street

The Park of Distraction

Gheorghe Sturza
Oil on card, 38 x 47 cm
Private collection

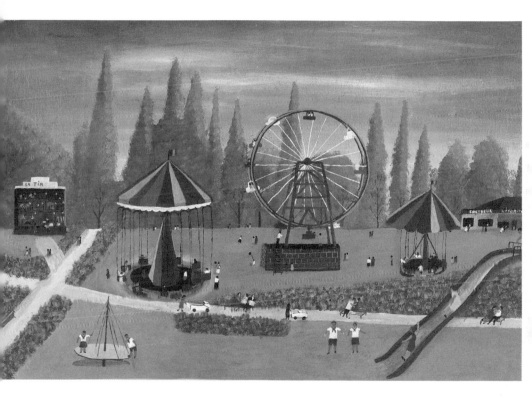

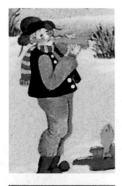

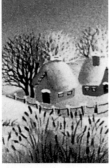

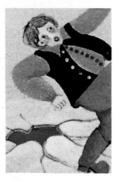

corner I encountered a woman who was selling Christmas tree decorations. The glass spheres, yellow and red, were shining in the sun as if she was holding a magic basket of apples, some yellow and some red. In this place – as in some others I have been to – I could feel a direct connection between wood and colour.'

The Fishermen

Paula Jacob
Oil on canvas, 40 x 50 cm
Private collection

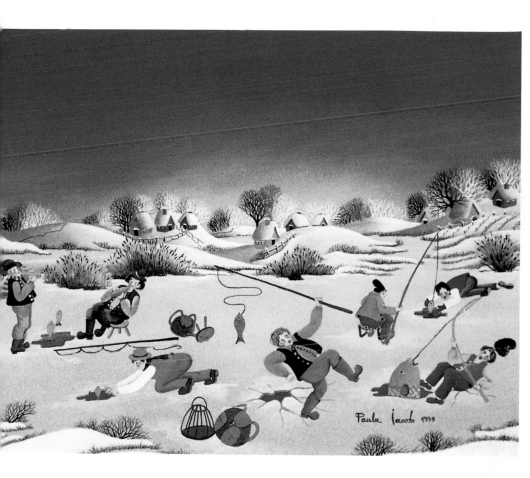

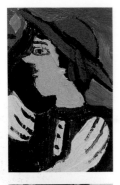

It was this multicoloured Russia which at the beginning of the twentieth century provided the impetus for a rejuvenation of painting, a new palette for the pictures of Boris Kustodiev, Vassily Kandinsky, Kasimir Malevitch, Ilya Mashkov, Pyotr Konchalovsky, Aristarkh Lentulov and Marc Chagall, together with those of Mikhail Larionov and Natalia Goncharova.

The Harvest

Ana Kiss
Oil on canvas, 42 x 48 cm
Private collection

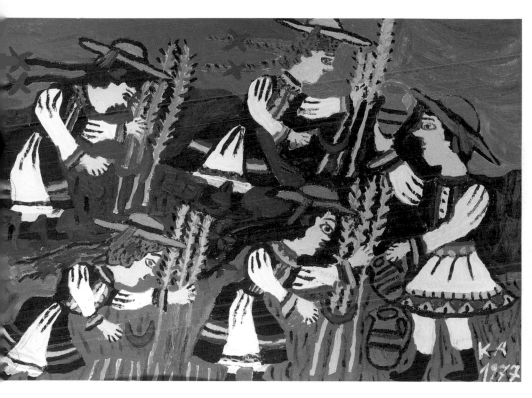

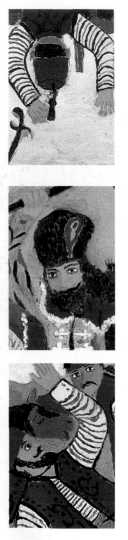

And it was here, among its thronging city streets and markets, at the junction of East and West, where talented but untaught painters were devising and executing their own works of art. The artists 'discovered' by Larionov could hardly be compared with Niko Pirosmani but the point is they existed! One of them has since become fairly well known.

Prince Michael Vitreazul and the Turks

Gheorghe Mitrachita
Oil on canvas, 60 x 80 cm
Private collection

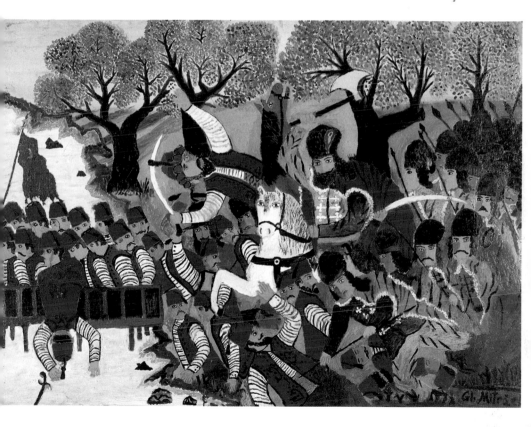

Morris Hirshfield was born in 1870 in what is now Poland but was then part of the Russian Empire. His pictures very much reflect the rural tastes of Polish life at the time, and feature clay cat-shaped money-boxes, wall hanging with butterflies, flowers and nudes.

Yellow Lion Sitting

Niko Pirosmani
Oil on cardboard, 99 x 80 cm
Georgian Museum of Fine Arts, Tbilisi

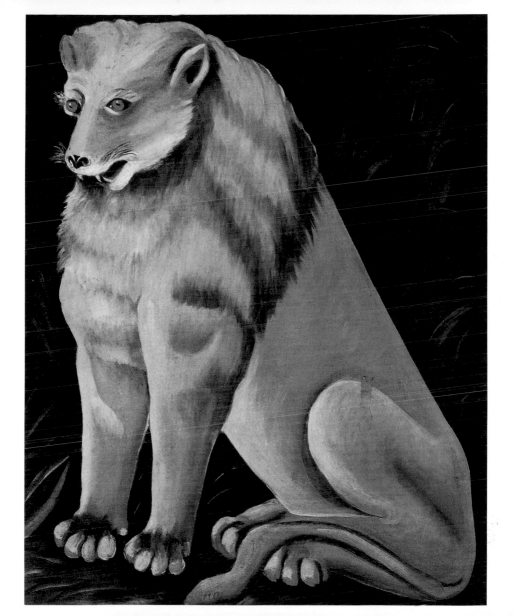

The pictures of Camille Bombois also have a lot to do with fairs (at one stage he earned his living as a wrestler in a travelling circus), only for the most part those of Paris. His vigorous depictions of athletes, circus shows and nude models are the very embodiment of Parisian street life of the time. For clear evidence of national traits in the work of Naïve artists we need look no further than Hegedusic.

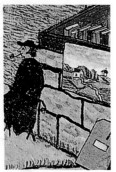

The Banks of the River Seine

Miguel Garcia Vivancos, 1957

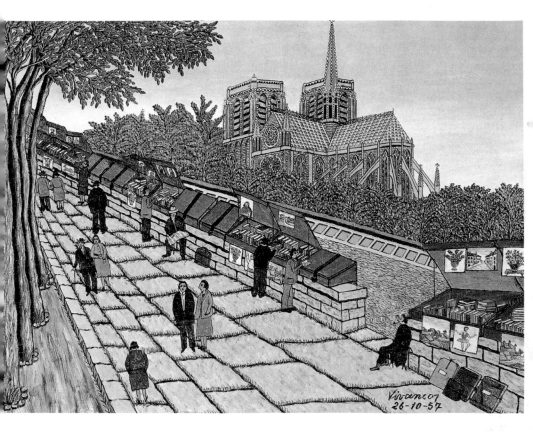

Vivancos
26-10-57

His intention was specifically to identify the roots of Croatian art, and to encourage works that represented those roots. The result was not so much an artistic school that he founded at the village of Hlebin as a collection of individual talents all working according to similar precepts. Brightest among his protégés was Ivan Generalic.

Haitian Landscape

Jean-Louis Sénatus

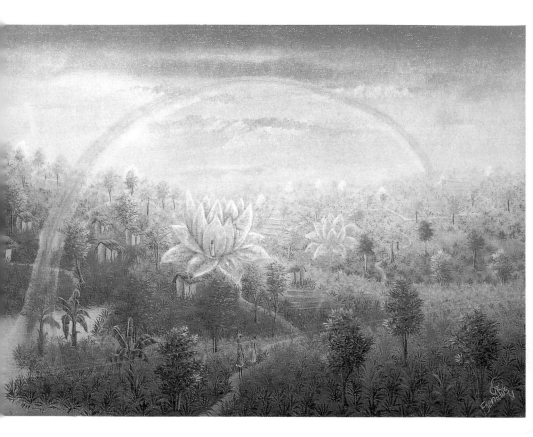

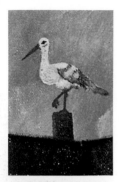

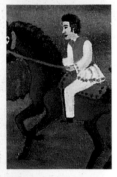

Ivan Generalic

Generalic was born in 1914, and for various reasons received only four years of formal education. He started painting on wood and glass (as was the custom in Balkan villages) and only later took to water-colour and oil painting on paper and canvas. In his approach to art he was a classic 'Sunday artist'.

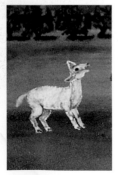

Festival Day

Gheorghe Dumitrescu
Oil on card, 35 x 48 cm
Private collection

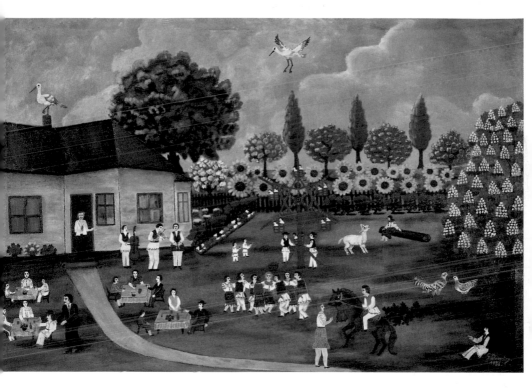

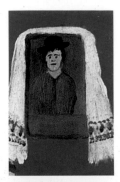

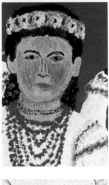

'Generalic is a peasant – a real peasant – who does all the work in the fields and in the vineyard himself,' wrote Robert Wildhaber, who visited Generalic in search of folk art objects to display in his museum in Basle. 'When he has time, and in moments of inspiration, he sits and paints on the very table on which he served us our dinner... His bedroom he uses as a picture gallery.

The Preparation of a Future Bride

Anuta Tite
Oil on card, 50 x 60 cm
Private collection

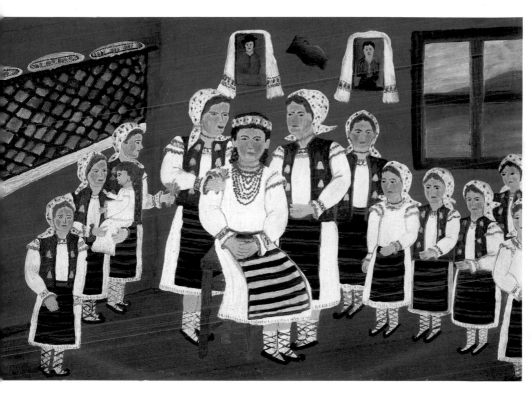

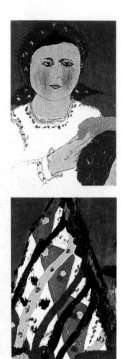

His own paintings hang there interspersed with photographs. His custom is to paint on glass – only rarely does Generalic work on wood. It is quite delightful how this thickset giant of a man with the strong hands of a peasant is apt to explain that the wood of a tree is hard, and he does not always feel its inner warmth, but that he always feels the inner warmth in glass.'

The Wedding

Anuta Tite
Oil on card, 38 x 45 cm
Private collection

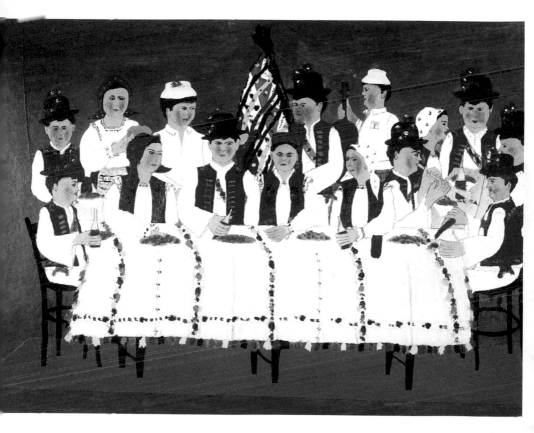

This last comment is especially interesting. Painting on glass has long been a traditional form of folk art not only in the Balkans but also in Switzerland, France, Germany and the Ukraine, whereas painting on wood has been the standard form for village craftsmen and icon-painters all over Europe and in much of the world.

The Dance of the Young Married Woman

Toader Turda
Oil on wood, 60 x 40 cm
Private collection

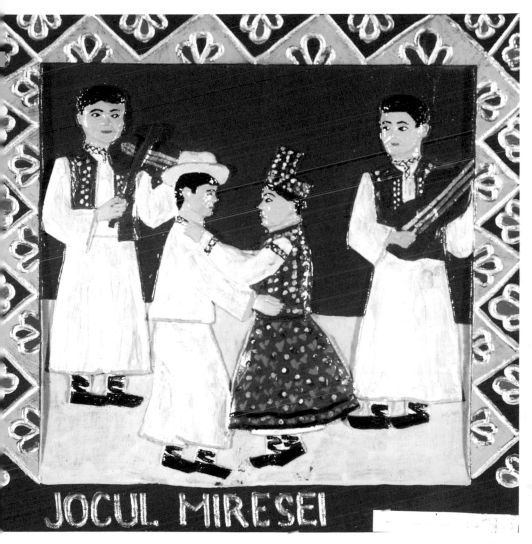

JOCUL MIRESEI

It is natural, then, that wood and glass tend to be the media on which Naïve artists paint their first works, if not all their subsequent works. Most of the talented rural painters of Hlebin have therefore continued to paint in oil on glass for the duration of their creative life; rarely have they ever crossed over to canvas.

Nightfall

Policarp Vacarciuc
Oil on canvas, 38 x 47 cm
Private collection

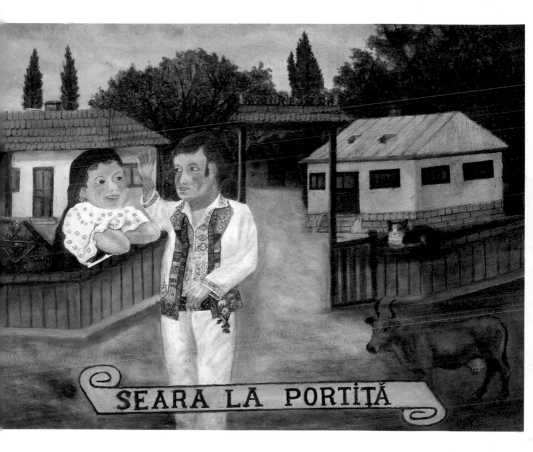

SEARA LA PORTIȚĂ

The connection with traditional, local arts and crafts by no means disqualifies village artists of anywhere in the world from the worldwide community of Naïve artists. Such rural pictures have every right to be regarded as a genuine easel-painting and to be compared with those of Rousseau.

Harvest Time

Viorel Cristea
Oil on card, 30 x 40 cm
Private collection

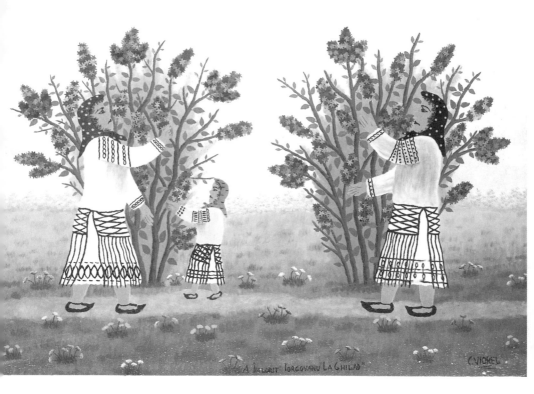

A ÎNFLORIT TORGOVANU LA GHILAD

Rustic artists acquired their devotees and their patrons, and their works have become prominent in many museum collections. In the comparatively small but diversely populated country of Switzerland, located right in the centre of Europe, there has long been concern that forms of folk art might disappear under the manifold pressures of industrial society.

Around the Mill

Mihail Dascalu
Oil on canvas, 80 x 100 cm
Private collection

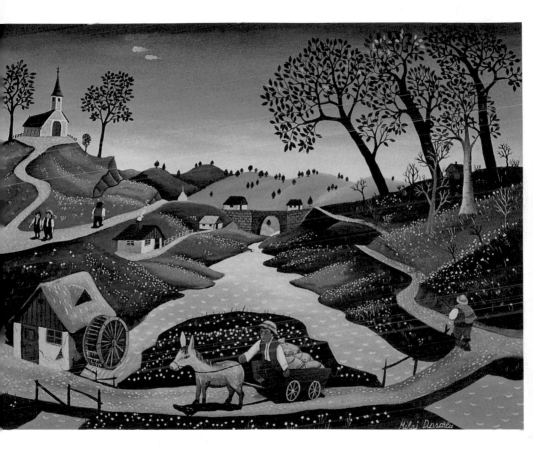

This is an area where the traditions of folk art exist perhaps less at the level of the nation than at the level of the canton: not only the artists themselves but the cantonal authorities too are very concerned to preserve what they can of their local culture.

Harvesting the Apples

Ion Nita Nicodin
Oil on canvas, 50 x 60 cm
Private collection

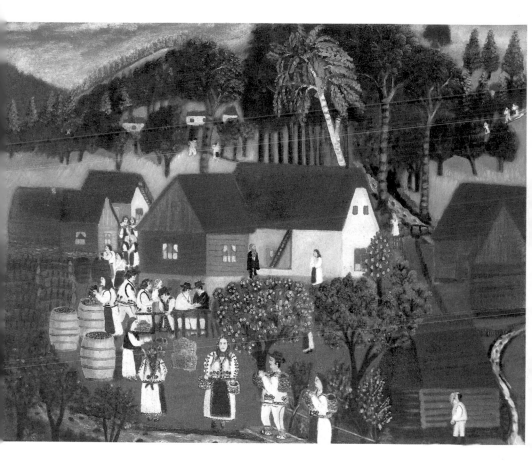

Oil painting on glass (and in particular, the works of René Auberjonois, of Lausanne) has received some notable commendation from 'professional' artists, which constitutes formidable support for it. Artists of truly rustic traditions, however, have tended to paint in oil or water-colour on cardboard, and their primary subject matter has been cows going up to an Alpine meadow.

The Sheepfold

Elisabeta Stefanita
Tapestry, 100 x 200 cm
Private collection

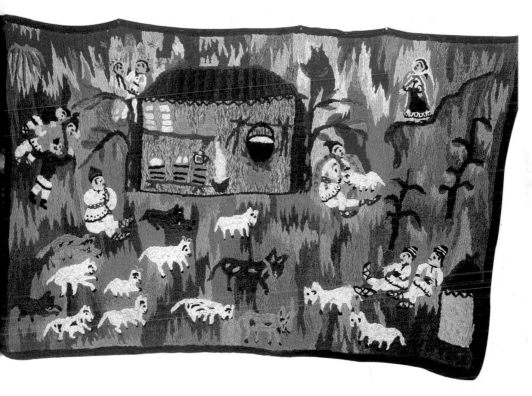

The oldest existing examples of paintings like this date back to the 1700s, although it is more than probable that such scenes really go back hundreds of years and focus on a geographical area surrounding the Säntis mountain group in the east of Switzerland, on the Liechtenstein border.

Ship with Butterflies and Flowers

Paula Jacob
Oil on canvas, 70 x 55 cm
Private collection

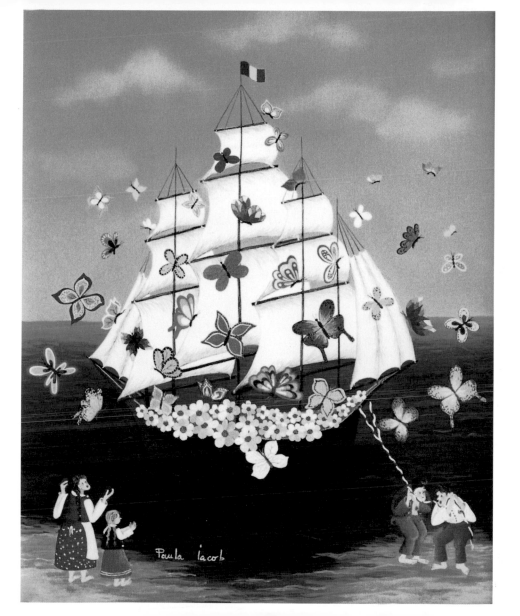

Paula Iacob

Sharp outlines and an individual sense of colour in these works make them reminiscent of the Russian lubok. Unlike a lubok, however, each Swiss scene is signed by its artist, and the names of some Swiss artists of this sort have been known since the nineteenth century. They have not been forgotten either, thanks to their individual style and perception of the world.

Red Horse
—————
Calistrat Robu
Oil on card, 60 x 45 cm
Private collection

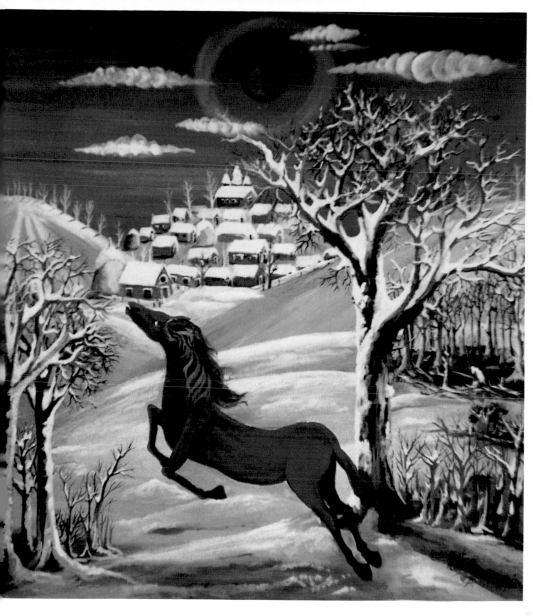

One of them was Conrad Starck, perhaps most famous for the painted scene with which he decorated a milking-pail. Typifying the local Swiss scenery as he knew it, there is a cow, slung around the neck of which is a huge cow-bell; there is a rustic labourer wearing a red waistcoat above yellow trees; a rather sketchy tree; and some dogs, without which no Swiss mountain-farmer could work.

The Giant Fish

Calistrat Robu
Oil on canvas, 70 x 50 cm
Private collection

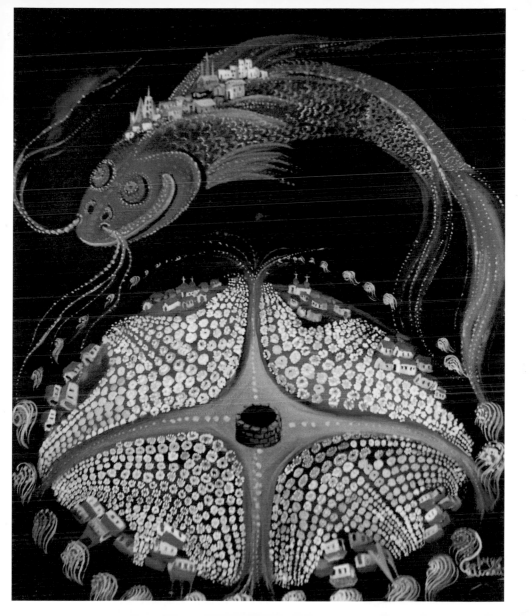

This somewhat stereotyped though uninhibited approach by the artist is of course excused by the fact that it is all simply decoration for a milking-pail. The same stock subjects are also included in another painting of a milking-pail by Bartolomäus Lemmer in 1850, although the painting is totally different. The labourer is striding forward with a confident gait, a pipe between his teeth, followed by a shabby dog.

The Organic Player of Barbary

Ion Gheorghe Grigorescu
Oil on canvas, 60 x 45 cm
Private collection

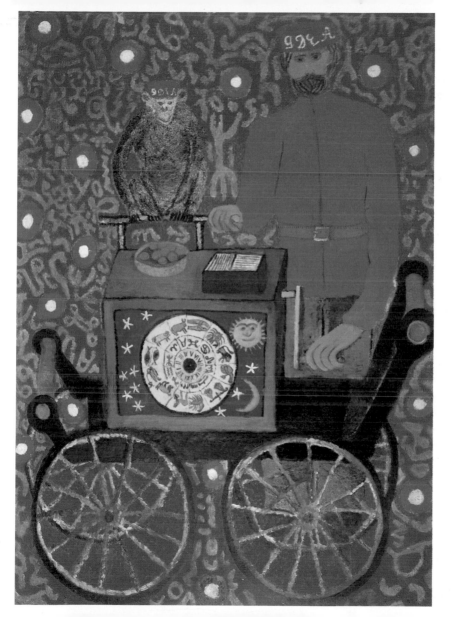

A group of large, not to say fierce, cattle charge towards him in the background. Such functional decoration is rarely painted with distinctive expressiveness or freedom. Many rural artists painted virtually nothing else but cows going up to an Alpine meadow, strangely clean farms, herds of goats and pigs, and the occasional yokel on a mountainside.

My Village in the Spring

Milan Rasic
48.5 x 39 cm
Croatian Museum of Naïve Art, Zagreb

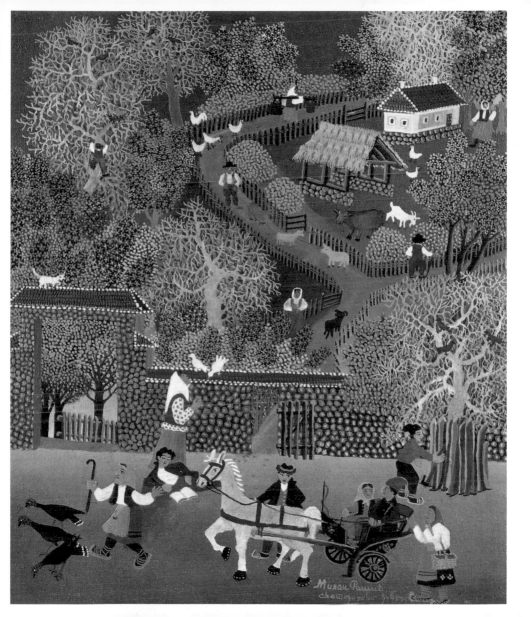

But each artist had his or her own way of painting. For the most part, the pictures were neither sensational nor innovative, especially when an artist was deliberately following an older, traditional style. Sometimes, just sometimes, the style is broad and free – a reminder that the artist has truly been part of the twentieth century.

Prince Michael Viteazul and the Turks

Mircea Corpodean
Oil on glass, 40 x 30 cm
Private collection

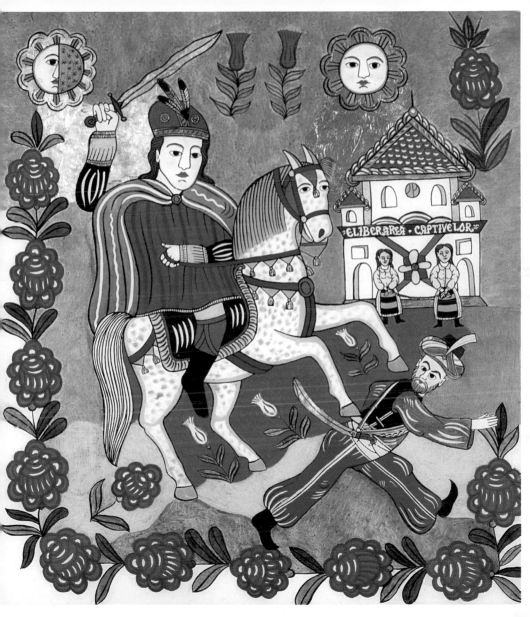

In this dual way, the artists have created an image of their country that is comparatively modern and have yet preserved the spirit of the art of their tradition. To quote the words of one of Henri Rousseau's defenders in the *Salon des Indépendants*, 'It is unreasonable to believe that people who are capable of affecting us in such a powerful way are not artists.'

The Attack

Gheorghe Sturza
Oil on canvas, 43 x 58 cm
Private collection

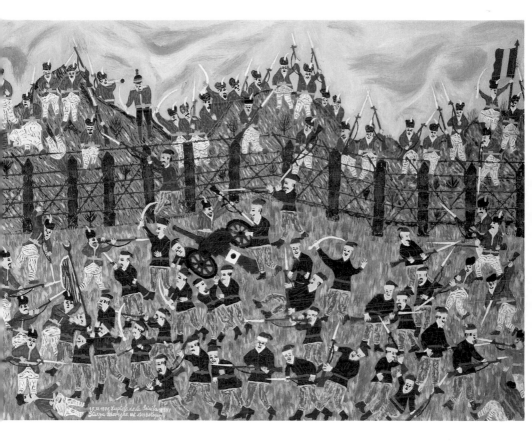

Naïve Artists and Photography

The end of the nineteenth century and the beginning of the twentieth gave Naïve artists another source of inspiration. By this period photography had become so practical that photographs – of parents, of brothers and sisters, of children and grandchildren, of entire family groups – decorated the walls of houses.

The Violin Player

Mihail Dascalu
Oil on canvas, 120 x 80 cm
Private collection

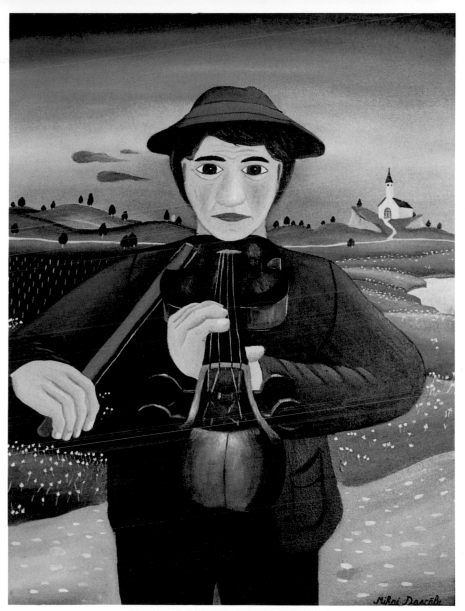

Mihai Dascălu

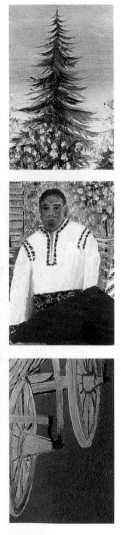

This is the way it was in Ivan Generalic's house. For many people, from the time photography began to 'compete' with painting, the qualities of a photograph represented aesthetic criteria. The result was that some artists were simply defeated by it. Others, like Edgar Degas, turned the world view, as seen through the lens of a camera, to their advantage.

Ox-Drawn Vehicle

Gheorghe Coltet
Oil on card, 42 x 56 cm
Private collection

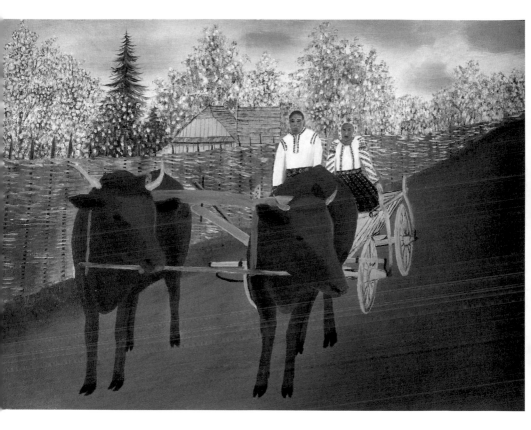

Now it was possible to commission from the local artist a portrait of your child which should 'look like a photo', because photography had that unique ability to catch and retain an image with the honesty of a mirror. No idealization was allowed, and the scrupulous rendition of every little detail of a face or of clothing was not only mandatory but tended to influence the poses people took up and the overall composition of the picture.

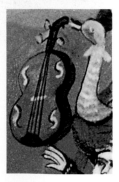

The Last Path

Ion Maric
Oil on canvas, 80 x 130 cm
Private collection

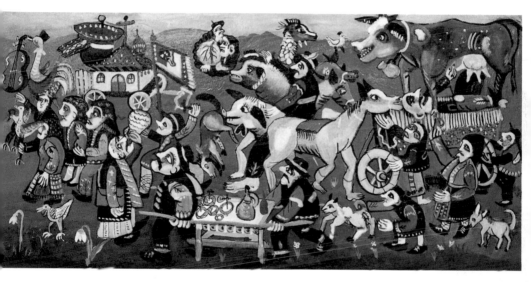

207

It is often because they reflect the standards of photography that pictures produced by otherwise very different Naïve artists – a French Rousseau, say, a Georgian Pirosmani, an Italian Metelli or a Polish Nikifor – may look similar. Rousseau's portrait of a female figure that was purchased by Picasso,

Allegory

Louis Vivin
Oil on canvas, 91.5 x 76 cm
Museum Charlotte Zander, Bönnigheim Castle

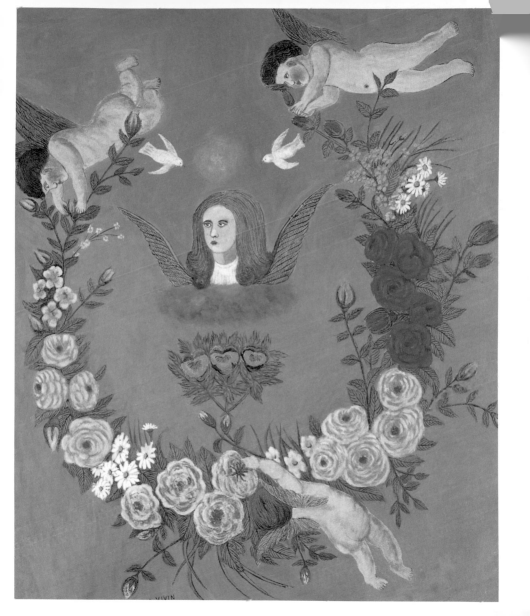

and even the Self-Portrait by Joan Miró, conformed in many ways to the aesthetics of photography – not perhaps to those of genuine artists with the camera but to those of the photographers at fairs, who sat their models one after another on the same plain chair in front of the same velvet curtain.

Self-Portrait as a Musician

Orneore Metelli

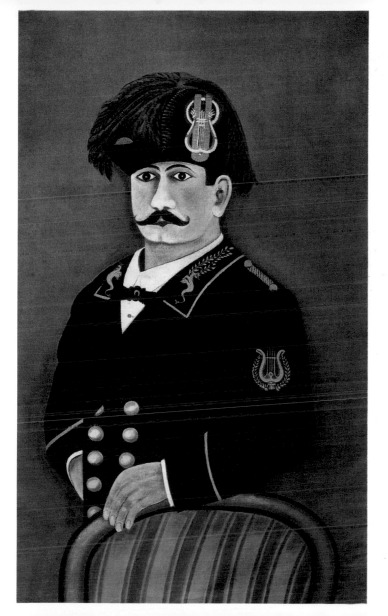

Whereas reproductions and prints of paintings were not widely available, photography soon became an established part of urban and rural life. Photographers were to be found at bazaars and fairs among the stalls of folk arts such as painted pottery and crockery, woven baskets and rugs, and wooden artefacts.

Nightscape
———————
Ivan Generalic, 1964
Galerie Mona Lisa, Paris

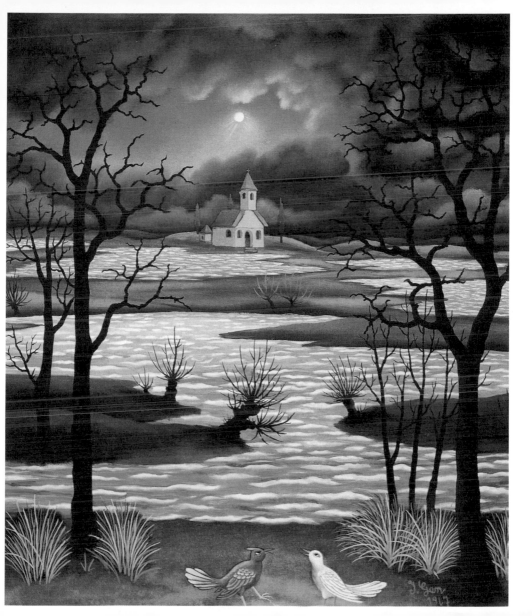

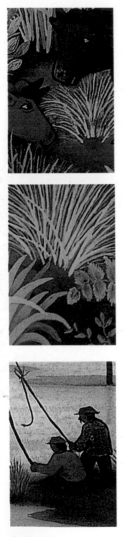

Photography entered every house as a form of art. Its influence on what people thought of 'art' is simply impossible to ignore. Naïve artists probably mastered the lessons of photography before the pros and cons of the medium in relation to professional art were fully appreciated by professional artists.

River Landscape

Ivan Generalic, 1964

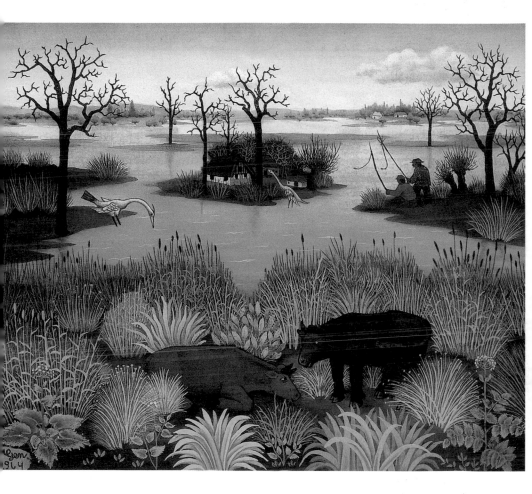

215

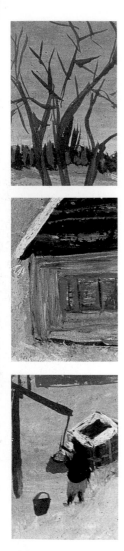

Is Naïve Art Really naïve?
Naïve Artists and Professional Artists

Once when I was in a small town in Estonia during the mid-1960s, I was lucky enough to meet an elderly landscape painter. With a small brush he was making neat strokes with oil-paint on specially prepared cardboard. In the foreground he was establishing a pattern of lacy foliage, while clusters of trees in the background created large circles.

Winter in the Countryside

Catinca Popescu
Oil on canvas, 30 x 40 cm
Private collection

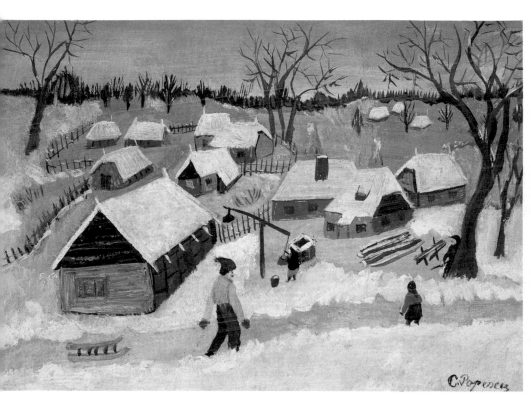

217

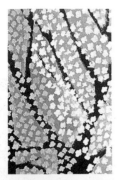

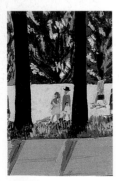

The elderly artist was building up spatial perspective according to the classic method – with a transition from warm to cold colours – although the contrasts between yellow, green and blue tonal values in the foliage were transforming what was an overgrown park into a magical forest. The artist told me that he had created his first works way back during his childhood. There then followed a gap of many decades during which he was employed at the local match factory.

Spring
———
Valeria Zahiu
Oil on canvas, 40 x 50 cm
Private collection

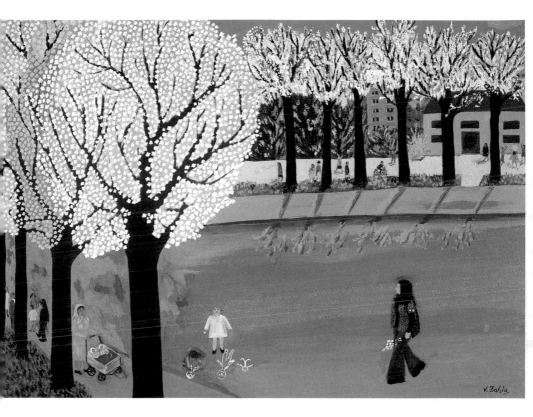

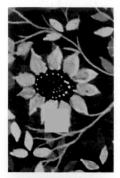

He returned to painting only upon his retirement. He insisted that he had never been outside Estonia, had never seen works of art at the Hermitage – the nearest large art museum (in St Petersburg, Russia) – had no knowledge about other European art or artists, had never himself attended any kind of formal art training, and was not acquainted even with any other 'Sunday artists'.

The Spellbound Tree

Camelia Ciobanu
Oil on canvas, 100 x 80 cm
Private collection

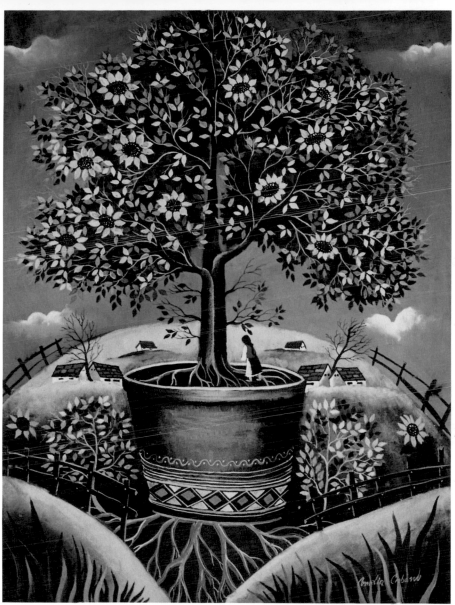

It was difficult to believe him, for his work was distinctly reminiscent of the landscapes of Jacob van Ruisdael, Meindert Hobbema and Paul Cézanne. If he was telling the truth, how can such a likeness be explained? If he was not telling the truth – why not? Not only did the most reputable Naïve Artist, Henri Rousseau, make no attempt to conceal his admiration for professional art – on the contrary – he made it evident on every possible occasion.

The Donkey who Made Money

Ion Gheorghe Grigorescu
Oil on canvas, 40 x 60 cm
Private collection

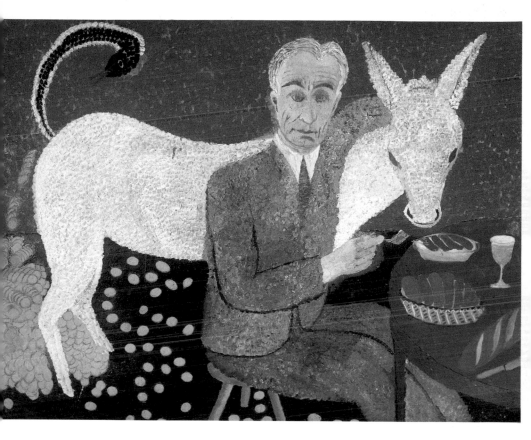

He idolized those professional artists who received awards at the salons and whose works were despised as academic banalities by the avant-garde artists. In his auto-biographical jottings he loved to name-drop, mentioning particularly advice given to him by Clément and Gérôme. When he received permission from the authorities in 1884 to make copies of paintings in the national galleries such as the Louvre, the Musée du

Flowers

Onisim Babici
Oil on canvas, 40 x 45 cm
Private collection

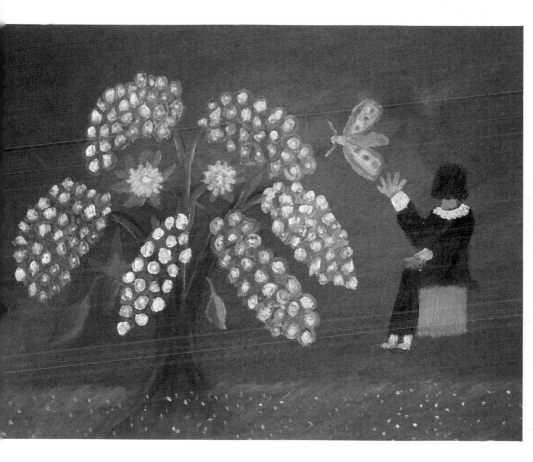

Luxembourg and Versailles, Rousseau told others (including Henri Salmon, who repeated it later) that he was going to the Louvre 'in order to seek the masters' advice'. His pictures thereafter testify that he knew how to put this advice into practice. The most diligent of Academy graduates might have been envious of his working method.

The Lilies

Constantin Stanica
Oil on canvas, 45 x 40 cm
Private collection

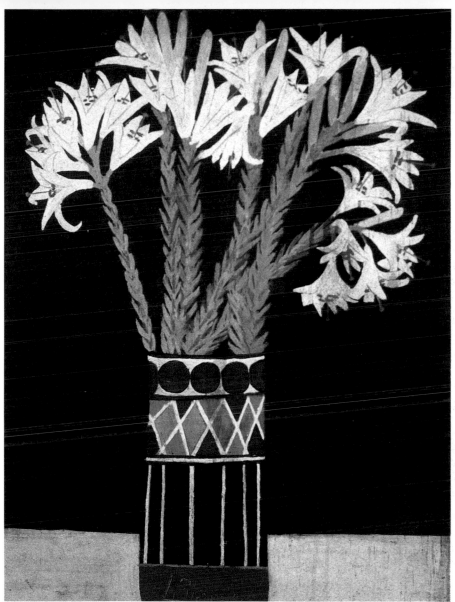

He made many drawing and sketches in situ, paid close attention to his painting technique, and thoroughly worked the canvas' surface. The condition of Rousseau's paintings today is much better than that of many of the professional artists of the time. His work was never spontaneous, details were never an end in themselves, and each picture has an overall integrity of composition.

General Staff Headquarters

Pavel Biro
Oil on canvas, 45 x 50 cm
Private collection

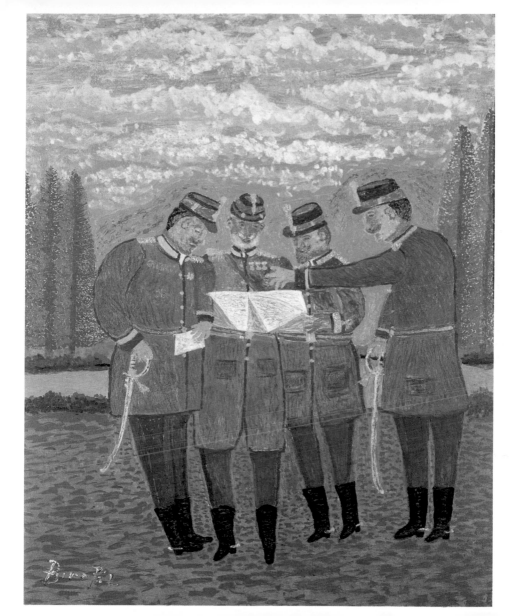

His virtuoso brushwork inspired admiration, and the refinement evident in his technique is reminiscent of the paintings of Jean-Baptiste-Camille Corot. It is in Rousseau's attempts to render perspective that his limitations become obvious. The lines often do not converge at the correct angle, and instead of receding into the distance his paths tended to climb up the canvas.

The Town Square

Branko Bahunek, 1974

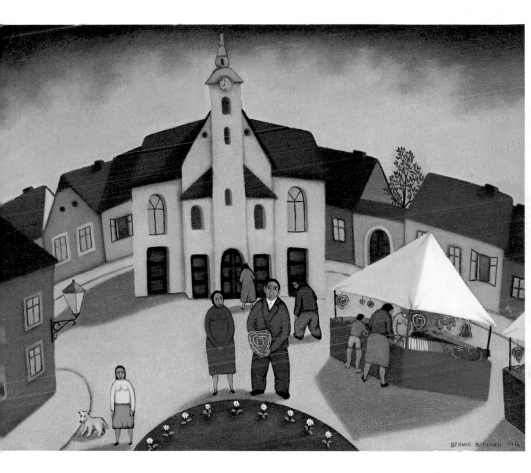

Perhaps we ought to remember, however, that Rousseau himself said in one of his letters that 'If I have preserved my Naïveté, it is because M. Gérôme... and M. Clement... always insisted that I should hang on to it.' But in view of the imperfections of his painting it is difficult to believe that they all stem from the deliberate rejection of the scientific principles of perspective laid down by Leonardo da Vinci and Leon Battista Alberti.

Folk Party by the Irtich River

Elena A. Volkova

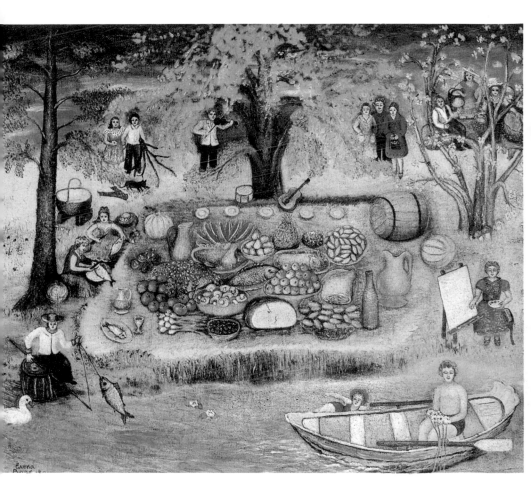

The history of art presents us with a number of excellent examples of artists who became professional only at a mature age and managed nonetheless to master that science of painting that comes much easier to those who are younger. The number is, however, not large. Only a few outstanding individuals – like Paul Gauguin and Vincent van Gogh – are capable of such achievement.

A Maiden from Siberia

Elena A. Volkova

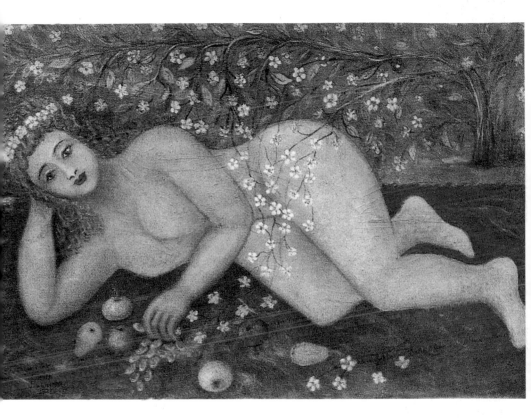

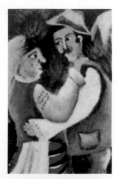

For all that, striving for the 'correct' way to paint and endeavouring to follow methods taught in art schools and practiced by the great masters is a trait present in almost every Naïve artist. Although Niko Pirosmani had no Hermitage or Louvre to visit, he was familiar with the works of other artists in contemporary Tbilisi, and tried to follow the professional 'rules' as far as he could.

Country Landscape with Cows and Sunflowers

Camelia Ciobanu
Oil on canvas, 80 x 80 cm
Private collection

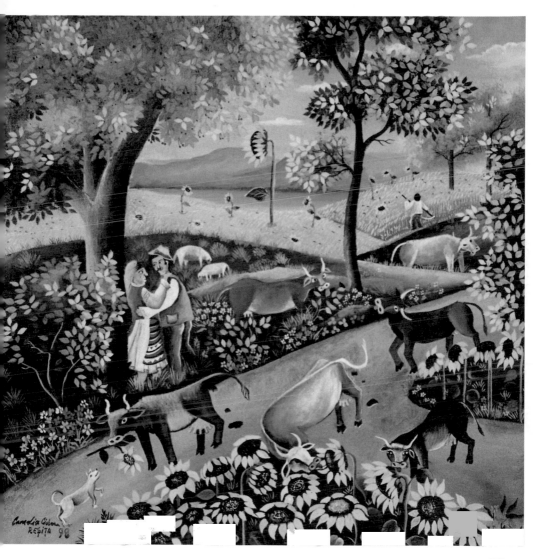

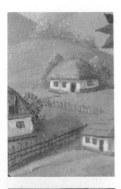

Perspectives in his landscapes, however, the anatomical proportions of his models and the positioning of human figures within his pictures were all prone to the errors also to be seen in the works of *Le Douanier* Rousseau. They reveal that characteristic awkwardness common to artists who start painting as adults. But like Rousseau, Pirosmani took great pride in his own individuality. Despite the amazing diversity of Naïve artists, then, their relationship with professional art is basically the same.

Harvesting the Fruits

Gheorghe Ciobanu
Oil on canvas, 35 x 45 cm
Private collection

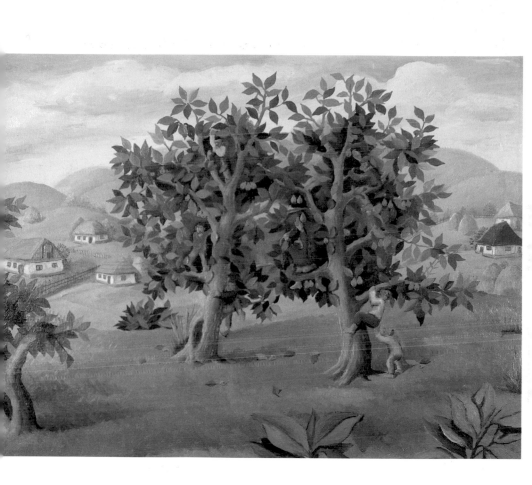

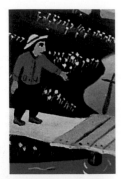

It would, after all, be extremely difficult to find a person who took up a brush and just started creating oil paintings without any previous knowledge of painting and without ever having seen the pictures of the great masters even by way of reproductions on postcards. Moreover, the seeds of this knowledge have fallen on to many different sorts of ground. The landscapes of Ivan Generalic, for example, are remarkable for their classical construction and spatial perspective.

The Broken Bridge

Mihail Dascalu
Oil on canvas, 50 x 70 cm
Private collection

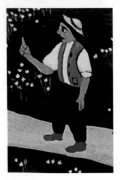

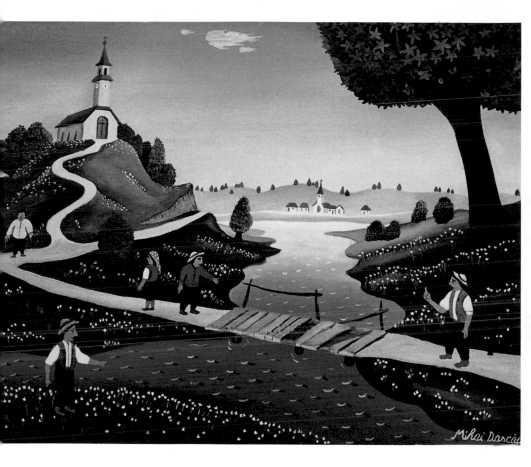

Generalic's figures move with such expression that those of Claude Lorrain and Pieter Brueghel spring to mind. He most probably owed these qualities to his mentor, Hegedusic. The other Croatian rural artists of Hlebin quite often established perspective in stages up the canvas, and their portrayals of the human figure were little or no more than childish. Analysis of Naïve art against professional criteria points to the conclusion that French and German, Polish and Russian, Latin American and Haitian artists all have some qualities in common.

Across Town by Cab

Emil Pavelescu
Oil on canvas, 80 x 100 cm
Private collection

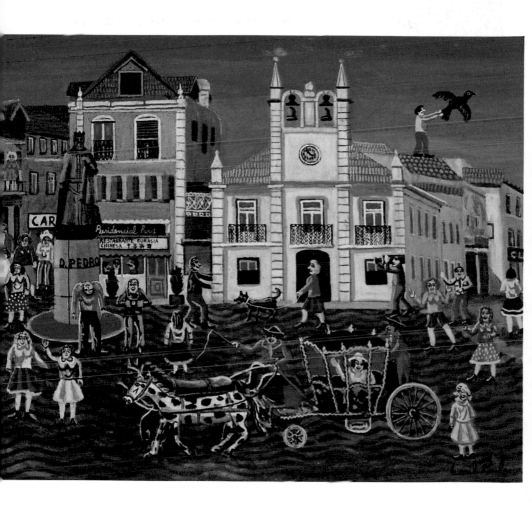

On the one hand all of them have a fairly clear idea of art as taught in art schools, and strive towards it. On the other hand they all possess that clumsiness which results in a characteristic manner of expression and which is itself responsible for the lack of balance in their works, resulting in outlandishly bold exaggeration or, conversely, in painstaking attention to detail. These, though, are the very qualities for which Naïve artists have become best known.

A View of Estoril

—————————

Emil Pavelescu
Oil on canvas, 80 x 100 cm
Private collection

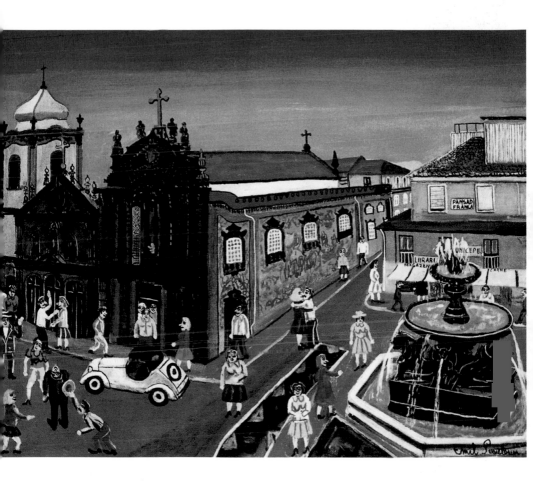

At the same time, if an adult person finds himself or herself striving earnestly towards an artistic goal and yet comes to the realization that his or her limitations make the goal unattainable, he or she might well be tempted to conceal any familiarity with the basics of art. Indeed, André Malraux once described Rousseau as being 'able to get what he wants like a child and being slightly devious with it'.

The Spellbound Tree

Mihail Dascalu
Oil on canvas, 120 x 80 cm
Private collection

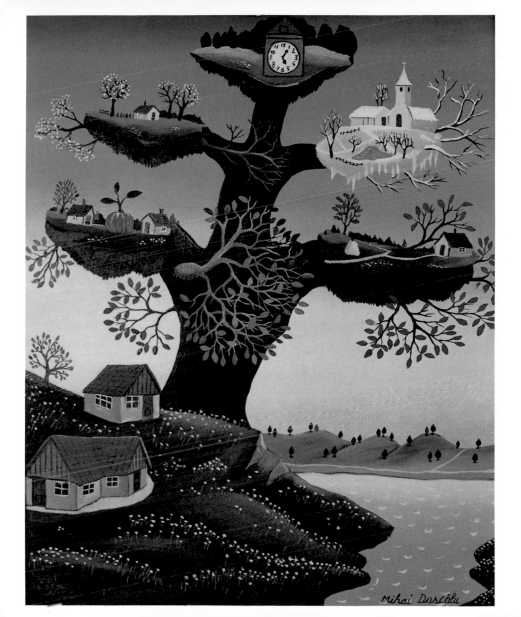

Mihai Dascălu

Index